HEROINES

HEROINES

PHOTOGRAPHS

Lincoln Clarkes

ANVIL PRESS | VANCOUVER

Heroines

Printed and bound in Canada

Cover and book design: Rayola Graphic Design
Author photo: Astrid Clarkes

Canadian Cataloguing in Publication Data
Clarkes, Lincoln, 1957–
Heroines

Includes bibliographical references and index.

ISBN 1-895636-45-0

1. Narcotic addicts—British Columbia—Vancouver—Pictorial works. 2. Downtown Eastside (Vancouver, B.C.)—Pictorial works. 3. Women—Drug use—British Columbia—Vancouver. I. Hodgson, Barbara, 1955- II. Title.

HV5824.W6C52 2002 779'.93061 C2002-910939-6

Represented in Canada by the Literary Press Group

Distributed by the University of Toronto Press

The publisher gratefully acknowledges the financial assistance of the B.C. Arts Council, the Canada Council for the Arts, and the Book Publishing Industry Development Program (BPIDP) for their support of our publishing program.

 Canada Council
for the Arts
Conseil des Arts
du Canada

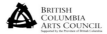 BRITISH
COLUMBIA
ARTS COUNCIL
Supported by the Province of British Columbia

Anvil Press
6 West 17th Avenue
Vancouver, B.C. V5Y 1Z4 Canada

To Astrid and Lucy

I especially wish to thank the women in this book who have allowed me to take their portraits, document their lives and their tragic circumstances. Without their confidence and courage, this photo essay would not have been possible.

I would also like to express my deep gratitude and love to family and friends who helped me through this project. The enthusiastic response of so many people has been overwhelming. It is impossible for me to list all of their names; they know who they are and I am so grateful for their encouragement and invaluable support.

Lincoln Clarkes
Vancouver, Canada.

her·o·in (her′ō in), *n.* *Pharm.* a white, crystalline, narcotic powder, $C_{17}H_{17}(OC_2H_3O)_2ON$, derived from morphine, formerly used as a sedative. The manufacture or importation of heroin is now prohibited by federal law in the U.S. because of the danger of addiction. Also called **diacetylmorphine, diamorphine.** [formerly trademark]

her·o·ine (her′ō in), *n.* **1.** a woman of heroic character; female hero. **2.** the principal female character in a story, play, film, etc. [< L *hērōĭnē* < Gk *hērōĭnē*, fem. of *hḗrōs* HERO; see -INE[2]]

Contents

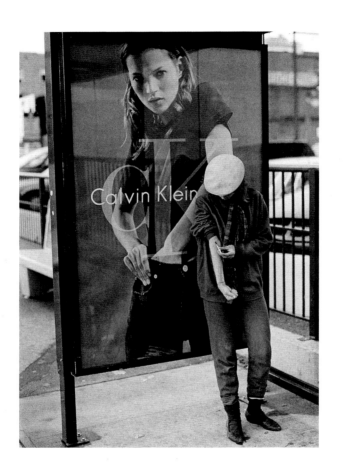

Leah

In any other city, this photograph might have been staged, but not here in Vancouver's Downtown Eastside. Crack-smoking, heroin-shooting, sleeping, eating, living, dying—it's all done on the street.

When you're N.F.A. (no fixed address), privacy is just a word.

I first met Leah in 1983 on the arm of my pal Jack Scrivener. She became a good friend: from parties to picnics, uptown to upcountry. We all did drugs recreationally, a good source of entertainment—use, not abuse. But Leah took a swan dive into heroin and all we could do was watch. Instead of people asking, "How's Leah?" everyone asked, "Is Leah still alive?"

The day this photograph was taken, in the autumn of 1996, I ran into Leah in Chinatown. I was with a friend, Heather, whom I introduced Leah to and who asked her, "Are you living in Vancouver?" "No, I'm dying here," Leah replied. She was on her way to the Sunrise Hotel to score some heroin. I excused myself and tagged along with her. Leah was sick, tired, dirty, lonely, humiliated and broke. Her husband had just died, and her daughter was living with her grandmother. We talked and laughed about the old days in the swinging art scene. She always asked about our mutual friends and remembered moments I had long forgotten. The thing she got most from me, next to money and a few tears, was time. And I enjoyed every minute.

She scored the heroin and needed to fix. We stepped into an alley but the stench was revolting. A bus stop was our shelter—Kate Moss, Leah and me. Soon she was in that narcotic dimension, an opiate dreamland of bliss.

After years of endless dramatic encounters and surreal situations, Leah asked me to help her escape the city. Somehow she acquired a thick wad of hundred dollar bills. I didn't ask. Once out of town, on an island, her detox began with opium tea, administered daily in a warm brew. She recovered from the withdrawal and within months she was back on the dance floor, and she was proud to be there. She found her friends and the weight she had lost. Her daughter was back in the picture and her family had opened their arms. She was the envy of the women who knew her in the heroin ghetto. Leah was on a roll, with grand plans.

One day Leah left three messages on my answering machine. I wasn't home and didn't even know she was back in town. She wanted to come over for tea and talk. It was Saturday, September 25, 1999. Leah overdosed that evening and was found dead on a bathroom floor in the Downtown Eastside. Alone.

Lincoln Clarkes
July 2001

Foreword

BARBARA HODGSON

"Under the influence of the drug, the woman . . . becomes 'a victim' in more senses than one. When she acquires the habit, she does not know what lies before her; later, she does not care. She is a young woman who is years upon years old."

— Emily Murphy, *The Black Candle*

Possibly the first Vancouver woman to be arrested on a drug-related charge was one of the nameless statistics in the city's Police Report for 1910. She had allegedly breached the "Medical Act," presumably the *Proprietary or Patent Medicine Act,* passed a year earlier to restrict the sale of medicines containing narcotics. Warrants to arrest six men had also been issued for the same infraction, while twenty-three additional men had been caught committing various other opium-related offences, thereby breaching the *Opium Act* of 1908 that prohibited the use of and trade in opium.

Ten years later, a Police Report noted that forty-seven women had been arrested for narcotics infractions, compared to 689 men. The rise in the number of arrests was a reflection of more laws instituted in the effort to limit the availability of opium and its offspring, morphine and heroin. And even though women were in the minority, that the number was even this high was shocking enough.

It would be simple to mistakenly use these statistics as evidence that drug use came to Vancouver in the opening decade of the 1900s, but in fact, Vancouver and opium have been closely connected since at least the 1880s, though Vancouver can't claim as long an acquaintance with the drug as Victoria, the older, and for many years, the more important of the two cities.

Opium was first brought to British Columbia by Europeans as medicine by the 1840s, if not earlier. The new emigrants' medical kits would have held morphine and the milder opium-laced laudanum and Dover's Powder, as well as a selection of patent medicines. These addictive, alcohol-based opium medicines were indispensable painkillers, but were often used as panaceas and for non-medical purposes.

The negative aspects of medicinal opium abuse had already been well publicized throughout Europe and North America, in part by essays such as Thomas De Quincey's *Confessions of an English Opium-Eater* (1821), as well as by pharmacists and doctors, who were trying to corner the distribution of drugs. In spite of the knowledge throughout the 1800s that opium was powerfully addictive, it was not until the first decade of the twentieth century that western nations, including Canada, passed laws radically restricting its use in medicines.

Opium was also introduced to the West Coast with the arrival of Chinese gold miners in the 1850s, taking the form of smoking opium, the demand for which engendered a local industry in the manufacturing of raw imported opium. Opium smoking, regarded solely as an Asian vice until the late 1800s, was both condemned and tolerated by Europeans. Condemned because it was seen as immoral and destructive; tolerated because government bodies profited from it through license fees and duty. So long as these taxes were paid and the opium fumes did not seep out of the Chinese quarters and infect Europeans—at least visibly—most people were content to leave it be.

Active efforts on the part of temperance-style organizations and from the Chinese community itself to try to eradicate opium smoking were unsuccessful in the short term, but they succeeded in drawing more attention to what was seen as a growing problem.

When Vancouver replaced Victoria in 1887 as a centre for shipping, Victoria's opium production declined and Vancouver's grew, though it never matched Victoria at its peak. In the 1890s, Vancouver and New Westminster housed several opium factories

and importers, along with numerous dens. Occasional newspaper reports appeared with headlines denouncing opium smoking, but it wasn't until Vancouver's 1907 Anti-Asian riots that the practice became well-publicized, as a result of a federal government inquiry into the riot. The sale of opium was outlawed in 1908, and further laws restricting possession and use were passed in 1911, 1919, 1920 and 1921.

Up until this time, North American opiate users were largely hidden away; whether smoking opium deep in the confines of a den, tippling laudanum in the bedrooms of middle-class homes or receiving a shot of morphine in a sanatorium, it amounted to the same thing: opiate abuse was well established among both men and women. Families or institutions had been burdened with the care of addicts and generally kept them out of society's way, but a new class was emerging: rootless men and women without ties or support. Their drug habits, along with the growing number of arrests, brought addiction out into the open.

It is apparent from the sensational newspaper articles of the time that stories about opium were written to grab attention. We can read of the arrests of Chinese opium den operators or of European opium smugglers, but it's the women who stand out: "Arizona Girl Was Thoroughly Doped," "Girl Was Enticed to Opium Den," "Woman Cleverly Hidden in Den," and "Woman Smuggler in Toils of the Law" are only a few of the headlines that graced the pages of Vancouver's *Province* and *World* newspapers.

Between the Opium Act and a concerted effort on the part of the police to close down dens in accordance with the new law, opium smoking declined but other opiate drug use grew. Addiction to opium medicines, as well as to morphine and heroin, fluctuated over the following decades but never entirely disappeared, and it's back with us today, stronger and more visible than ever, thanks in part to the further erosion of family and society ties. Now it's impossible to ignore. Women addicts openly beg for money, sleep in bus shelters, and shoot up in the alleys behind schools, shops and homes. At these disturbing sights many of us rush blindly past, unable or unwilling to recognize the human being behind the degraded façade.

The work featured in this book draws attention to the dreadful and very lonely state of these women. Clarkes' portraits give them back something that they all lost somewhere along the way: identity. And his fashion-trained sensibility offers us—in the composition and the poses of his subjects—painful ironies that can't be dismissed. From out of their photographs, the women look us in the eye. We can't help but look

back; we are involved in an uncompromising and equal scrutiny. Suddenly we see them: some of them beautiful, some plain, some young, some old, all ravaged by the drug that they're chained to.

Clarkes photographs the women in their own none-too-pretty environments. They stand against crumbling brick walls in alleys that reek of garbage and urine. His work, as social documentation, parallels that of Jacob Riis' 1890s Bowery photographs; Arnold Genthe's San Francisco photographs of the turn of the century and, especially, Lewis Hine's chronicle of labour conditions during the emerging twentieth century. But there is a substantial and fundamental difference between his work and that of others. Using his background in fashion, he doesn't just capture a moment in the lives of these women; he collaborates with them. Their response to him as photographer is one of trust. For him, they tame their hair, spruce up their clothes, stand tall. Sometimes, they even muster a smile. In the process of being photographed, they find dignity; they know that not only is the camera's eye on them, but the eyes of strangers as well, strangers who would pass them on the street, seemingly without so much as a second's glance. Clarkes clearly has a deep sympathy for his subjects, but his approach cannot be mistaken for charity; it is, rather, humanity.

Clarkes' work has brought international attention to the plight of women addicts. The fact that this series is set in Vancouver is immaterial; most Western cities share the problem. Having one's photograph taken and displayed will not cure a heroin addiction; it does, however, encourage people to remember that addicts are not nameless outcasts, and that we all have a responsibility to recognize their struggle to survive.

THE PHOTOGRAPHS

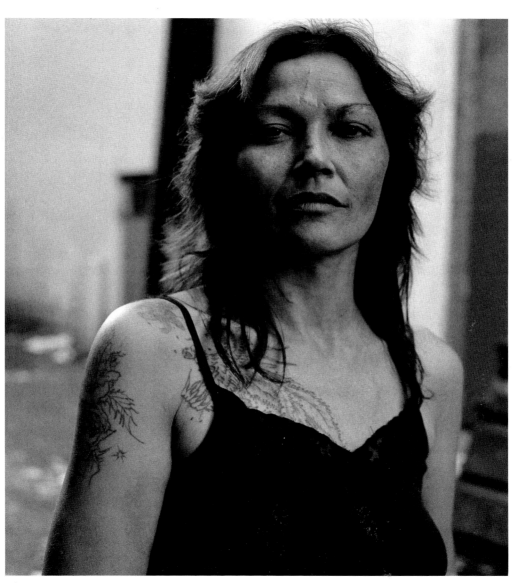

1

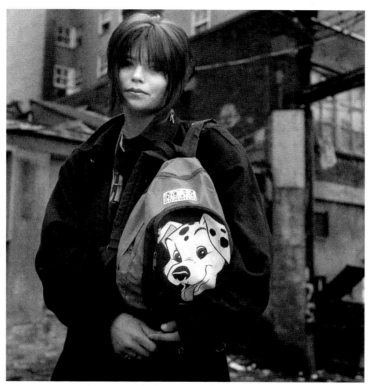

3

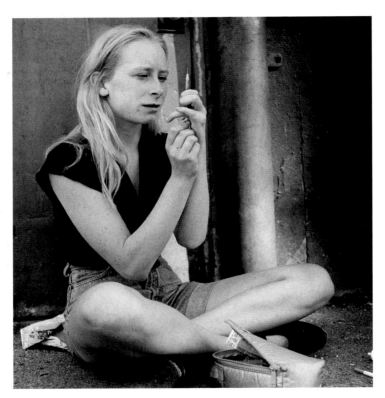

4

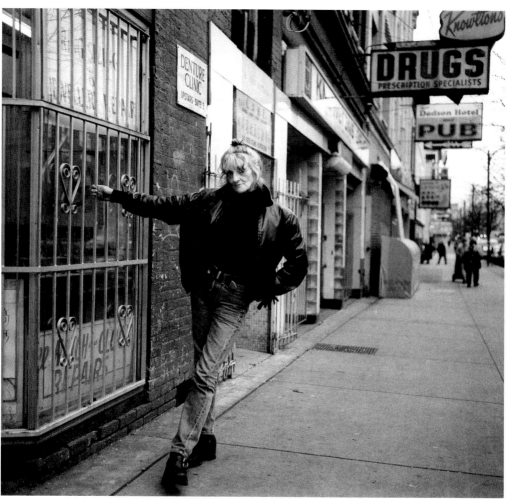

5

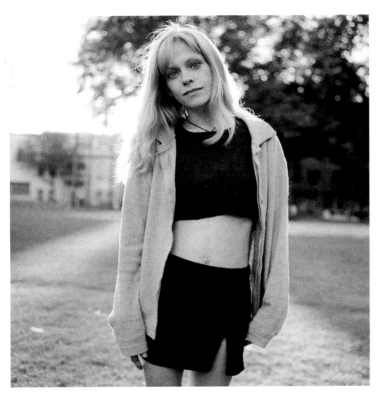

6

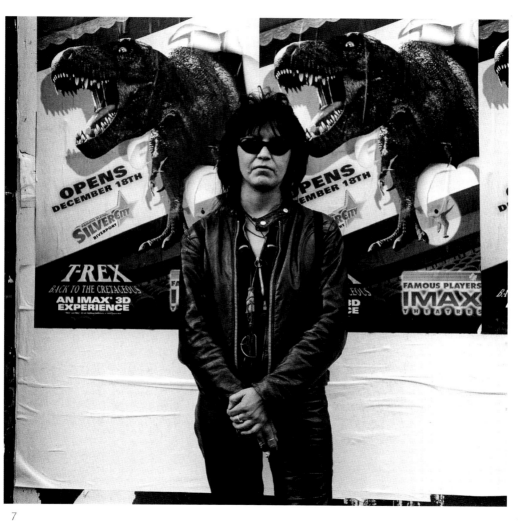

7

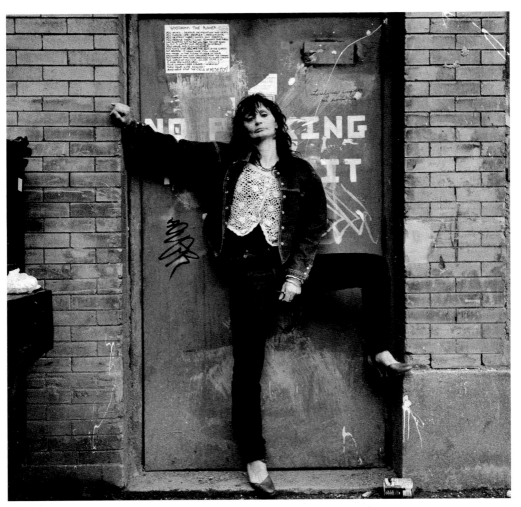

8

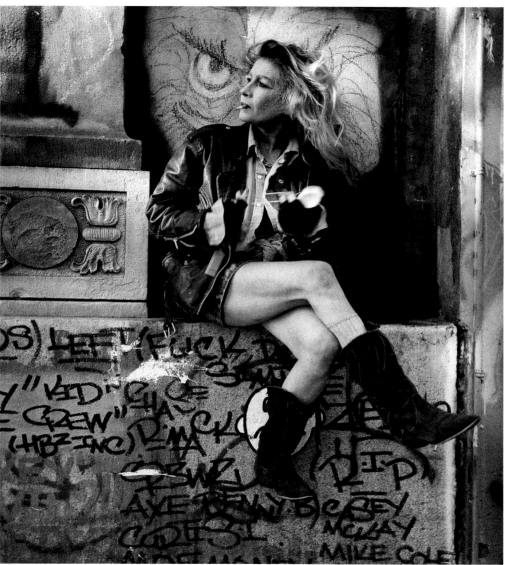

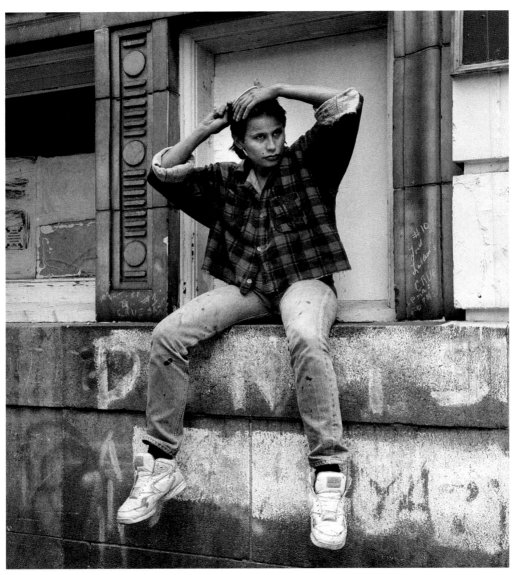

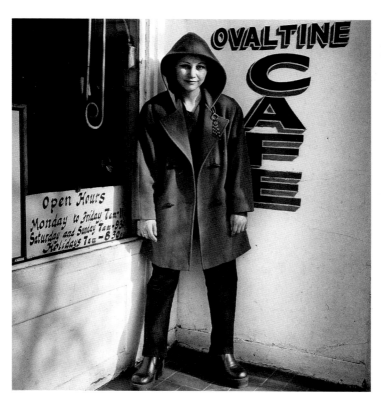

11

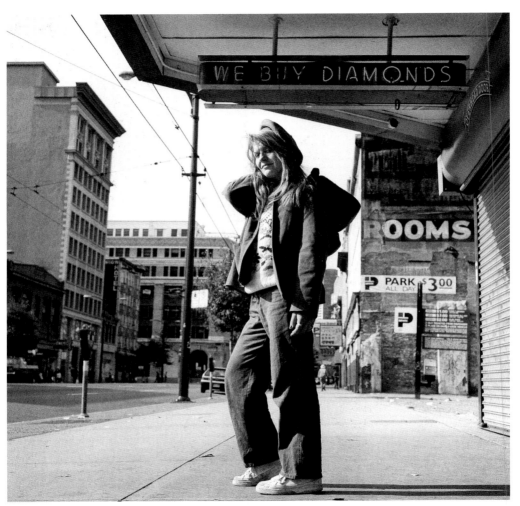

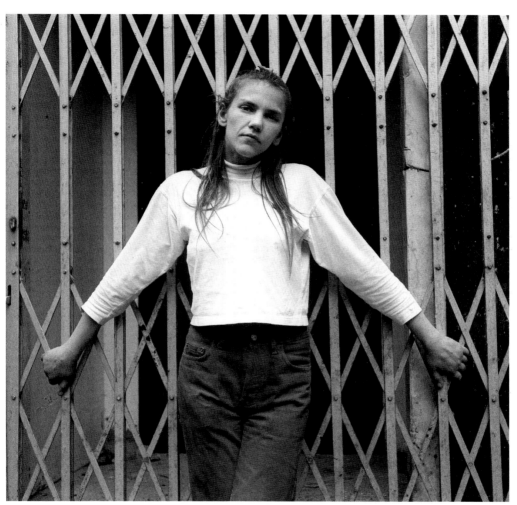

13

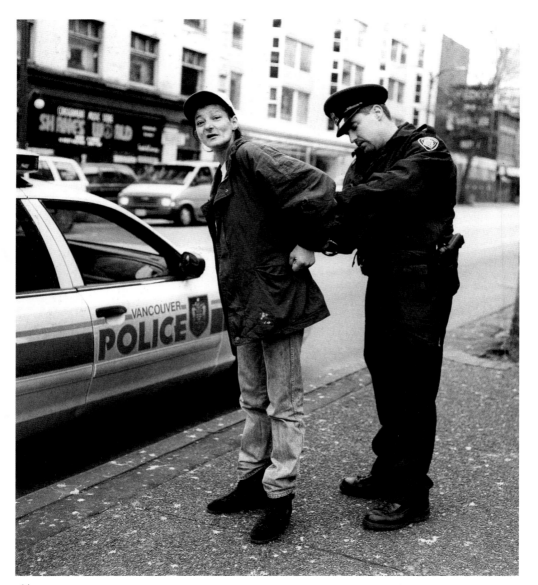

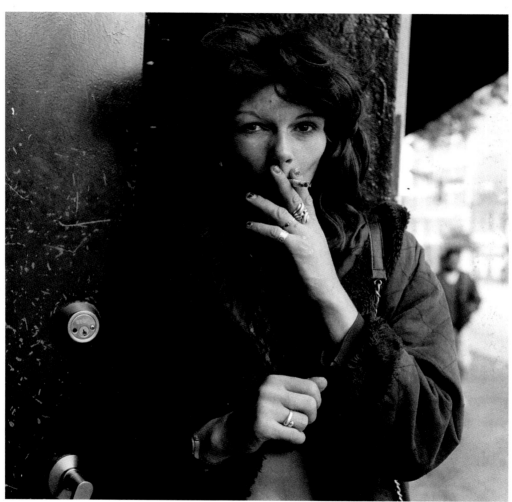

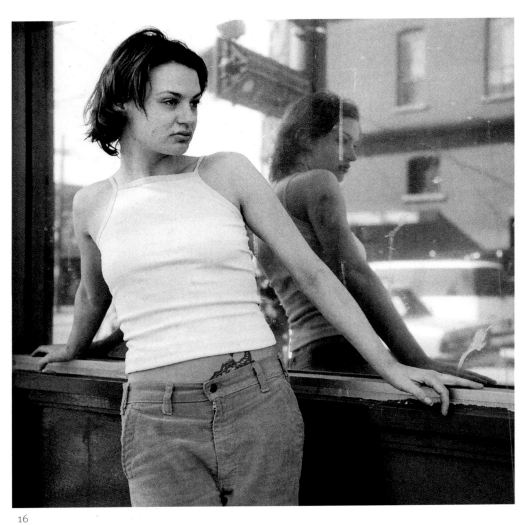

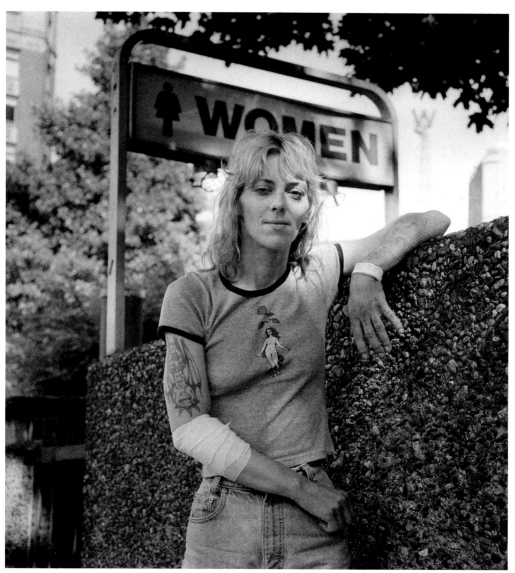

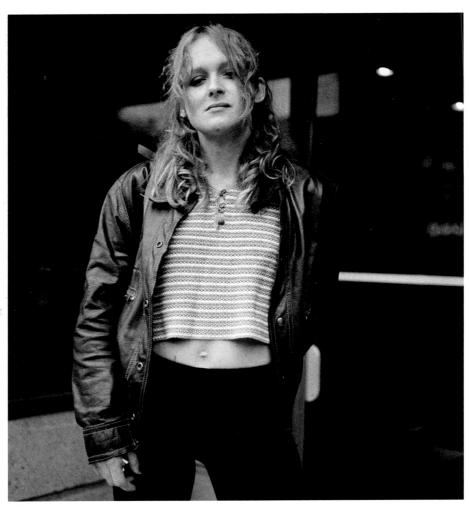

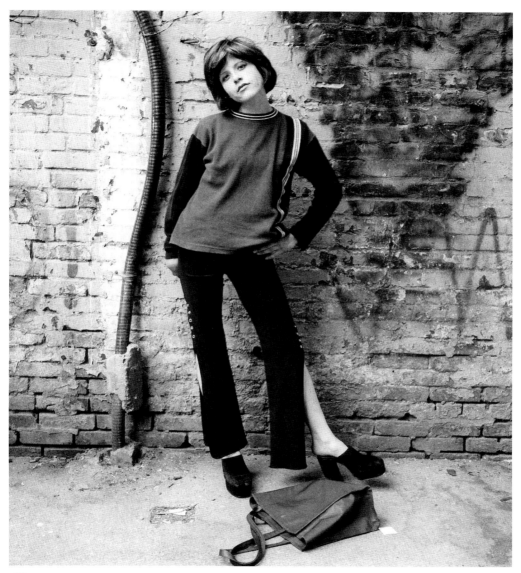

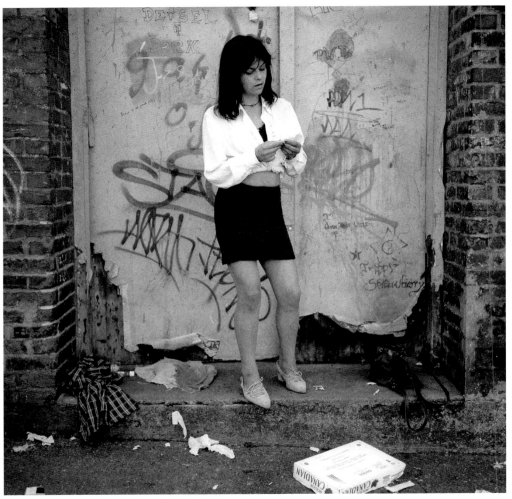

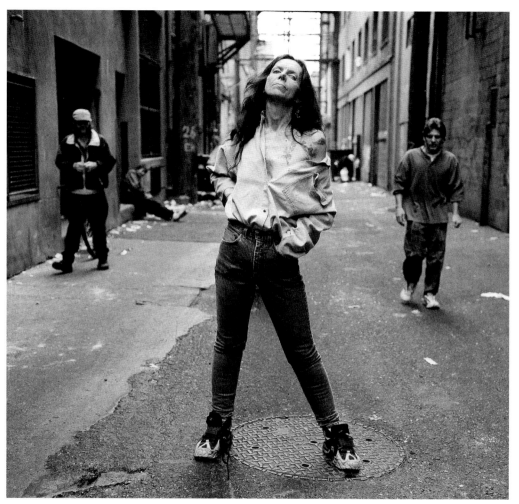

23

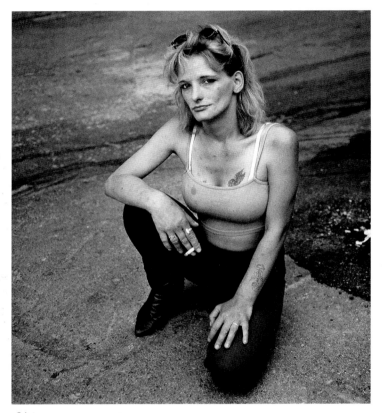

24

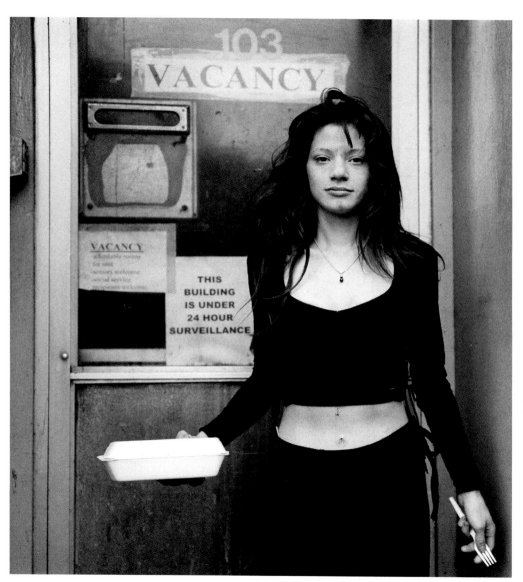

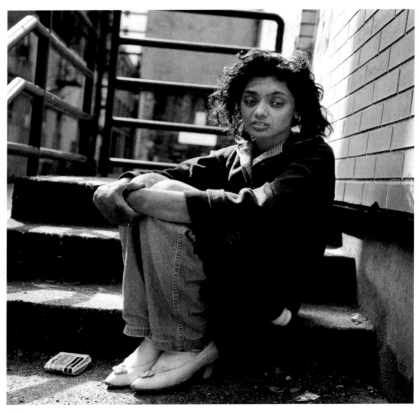

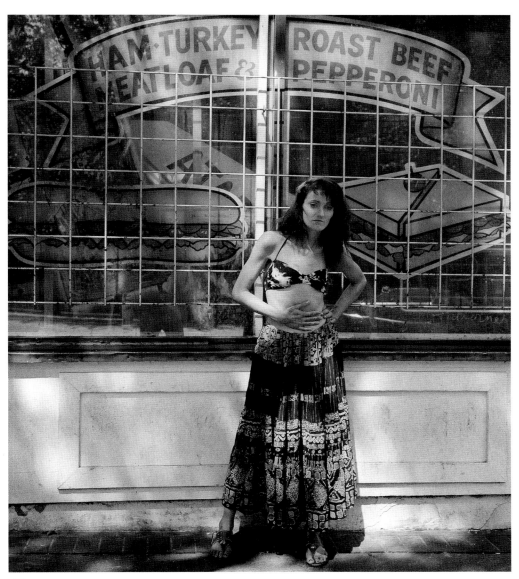

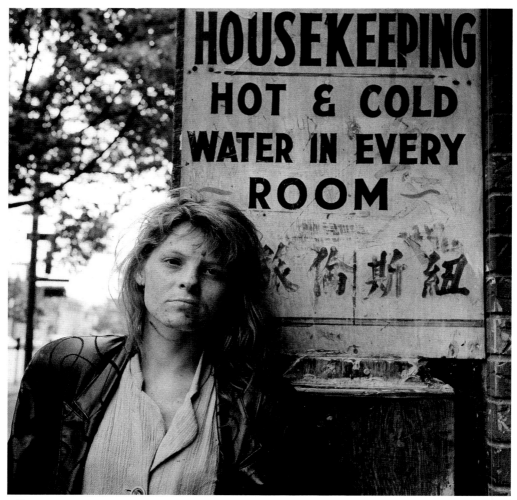

The sign on the building reads:

HOUSEKEEPING
HOT & COLD
WATER IN EVERY
ROOM

欧伯斯纽

28

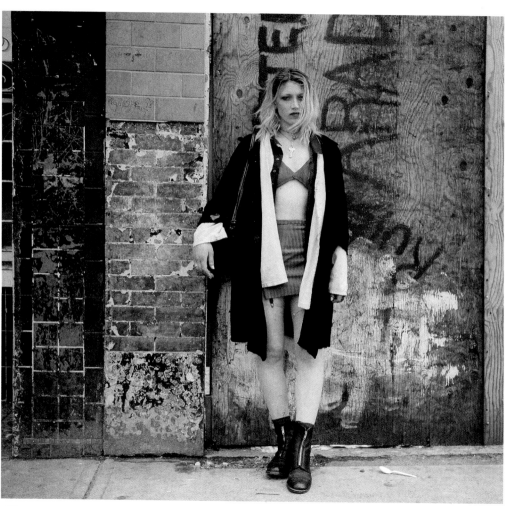

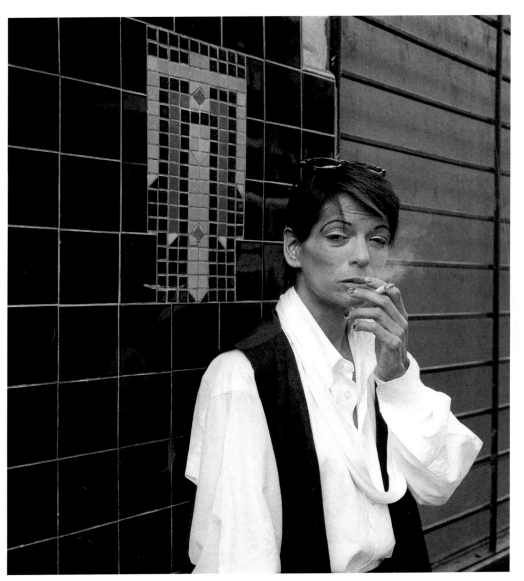

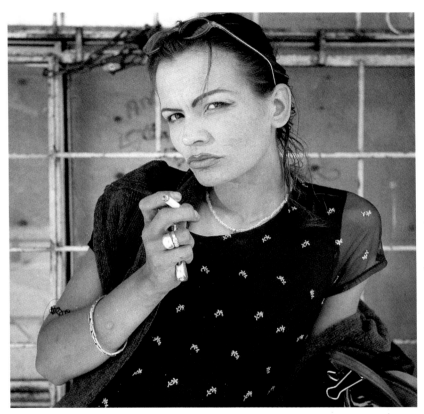

31

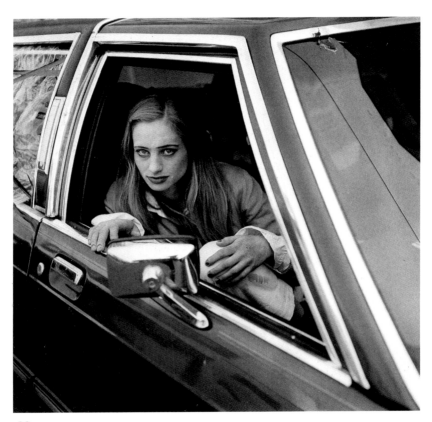

32

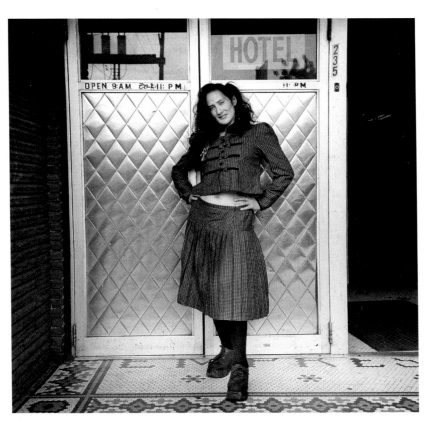

33

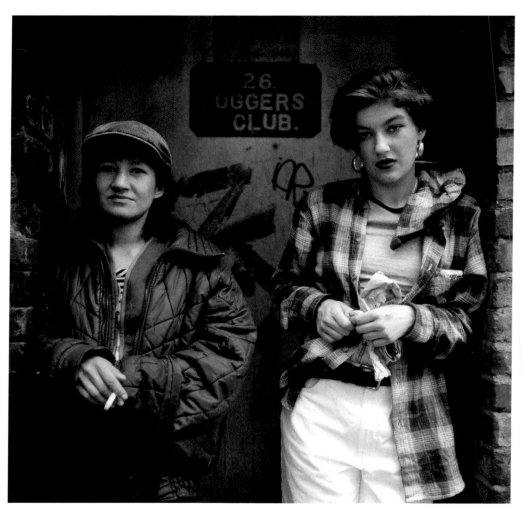

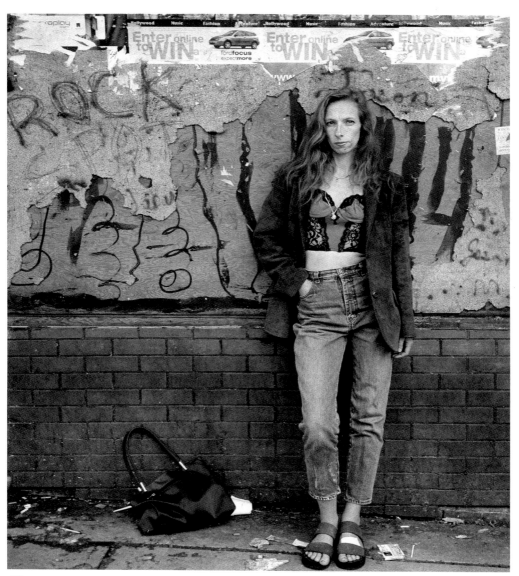

35

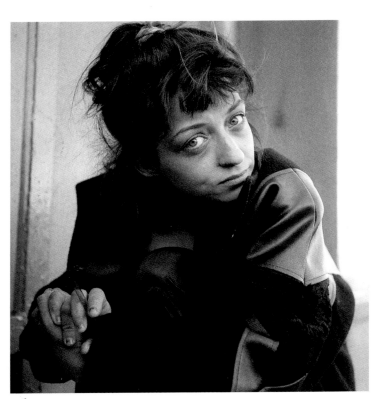

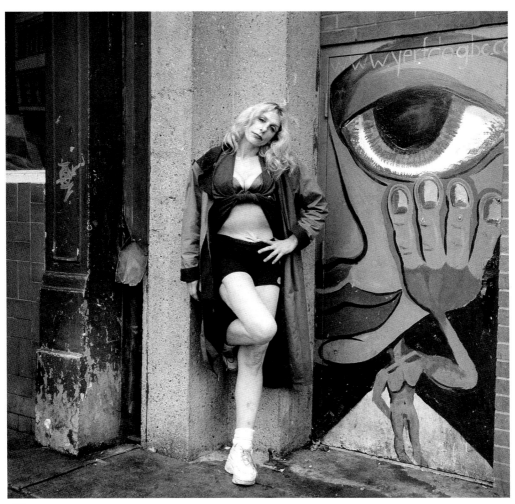

37

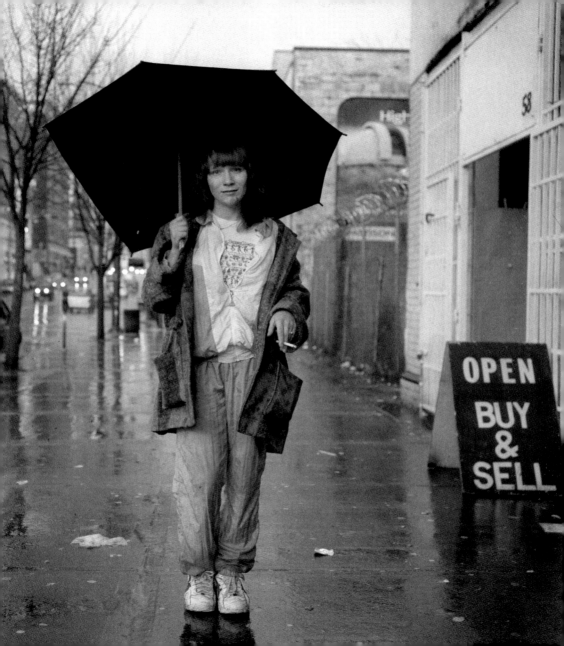

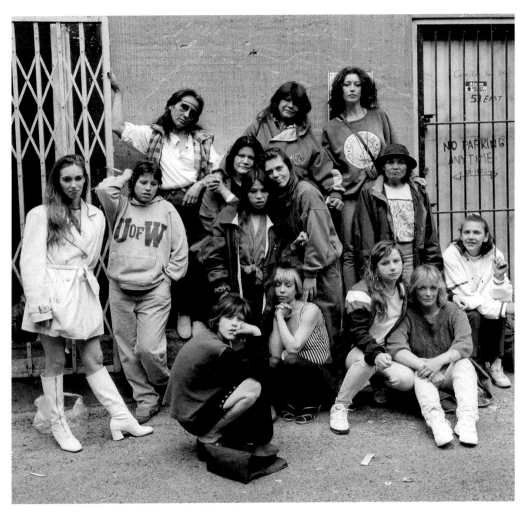

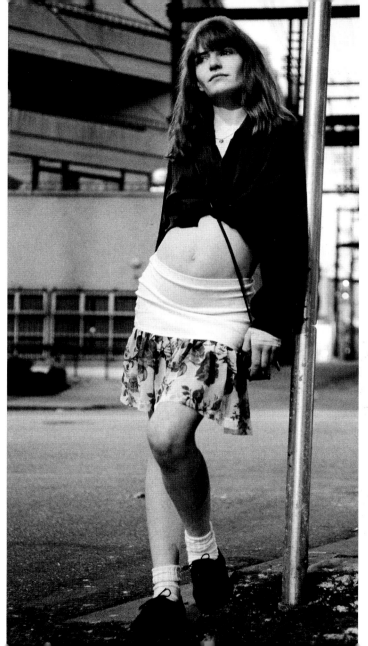

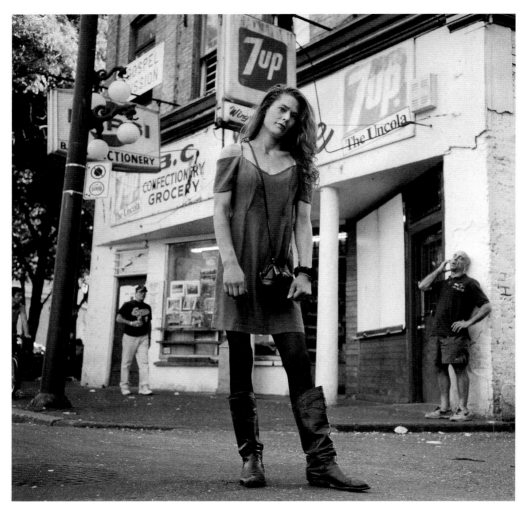

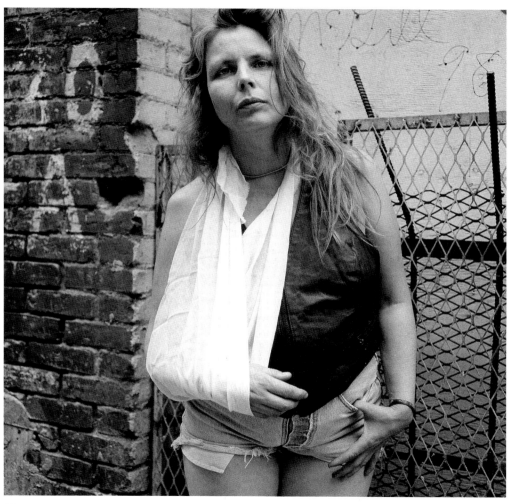

42

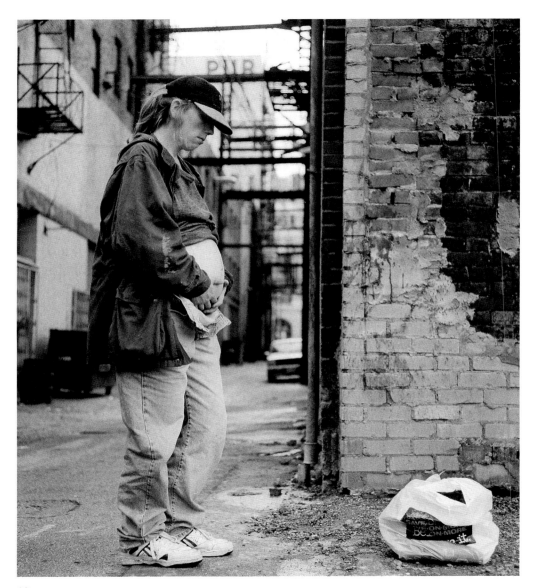

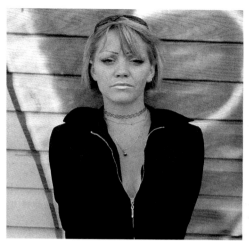

44

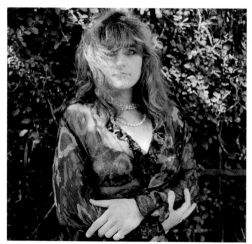

45

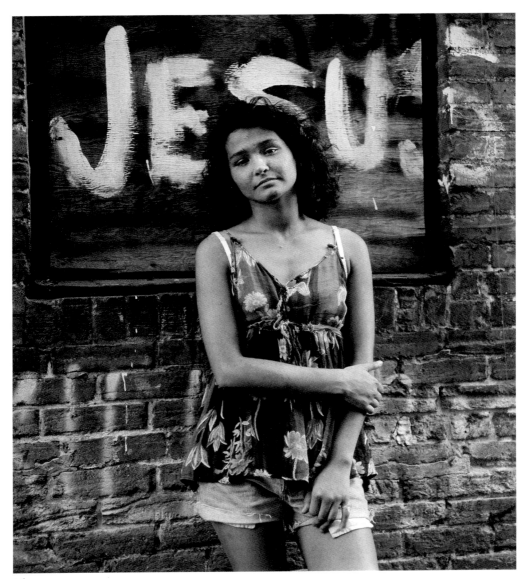

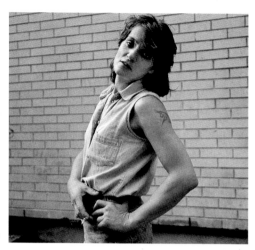

47

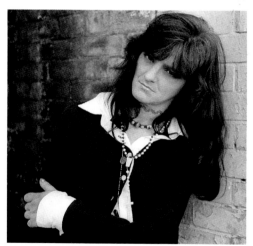

48

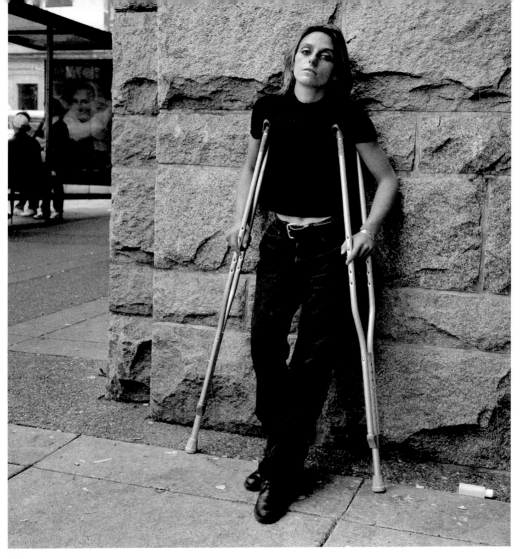

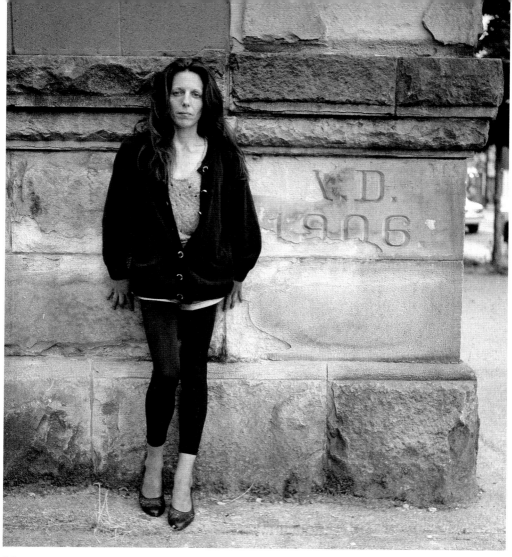

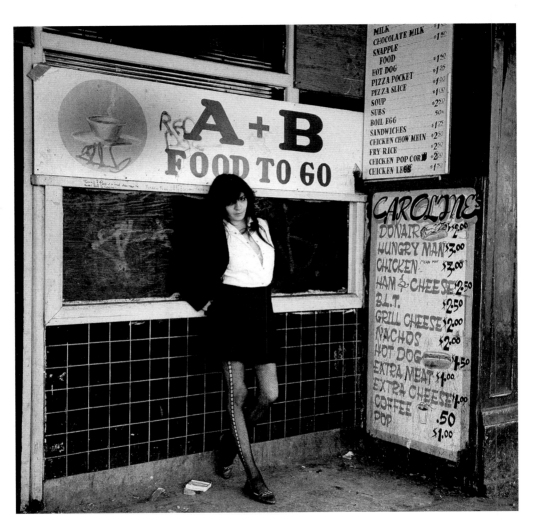

MILK $1.00
CHOCOLATE MILK $1.50
SNAPPLE
 FOOD $1.50
HOT DOG $1.25
PIZZA POCKET $1.00
PIZZA SLICE $1.00
SOUP $2.50
SUBS 50¢
BOIL EGG $1.25
SANDWICHES $2.50
CHICKEN CHOW MEIN $2.50
FRY RICE $2.50
CHICKEN POP CORN $2.00
CHICKEN LEGS $1.50

RecA + B
FOOD TO GO

CAROLINE'S
DONAIR $2.00
HUNGRY MAN $3.00
CHICKEN $3.00
HAM & CHEESE $2.50
B.L.T. $2.50
GRILL CHEESE $2.00
NACHOS $2.00
HOT DOG $1.50
EXTRA MEAT $1.00
EXTRA CHEESE $1.00
COFFEE .50
POP $1.00

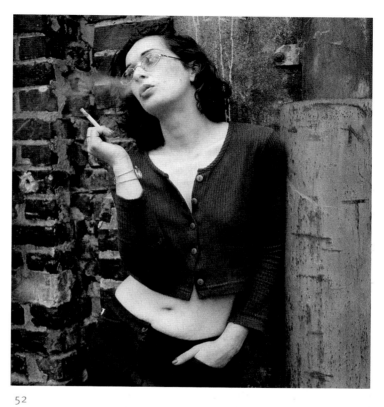

52

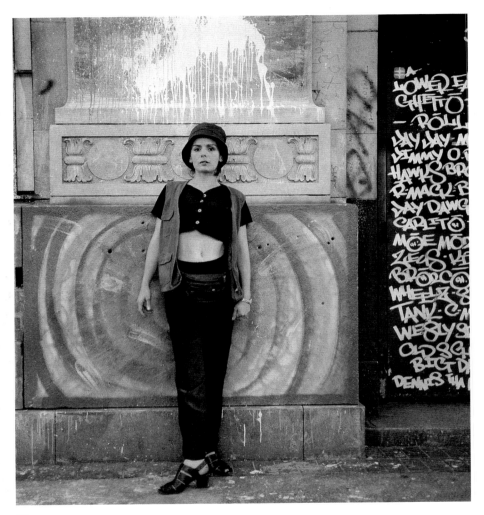

53

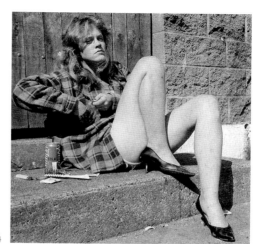

54

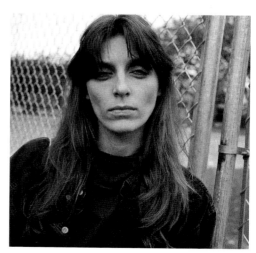

55

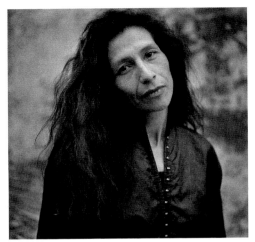

56

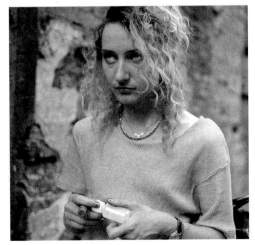

57

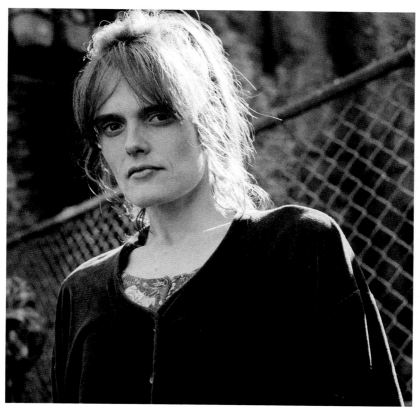

58

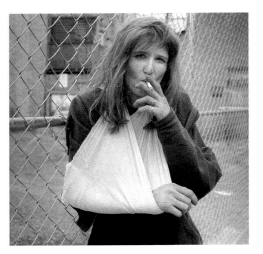

59

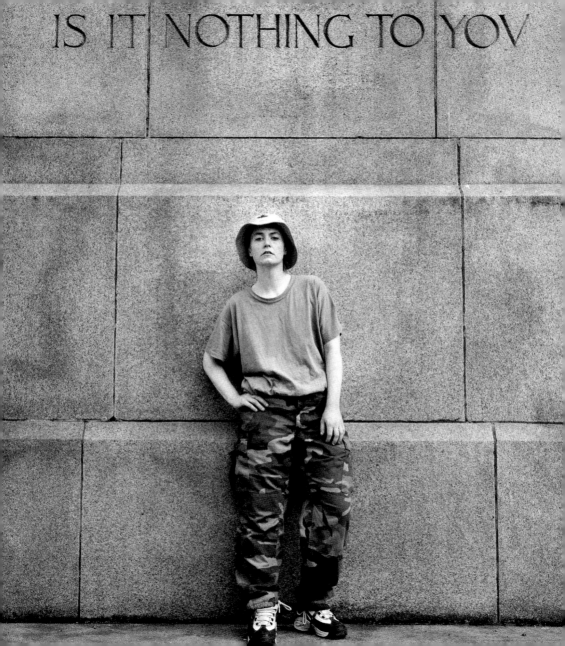

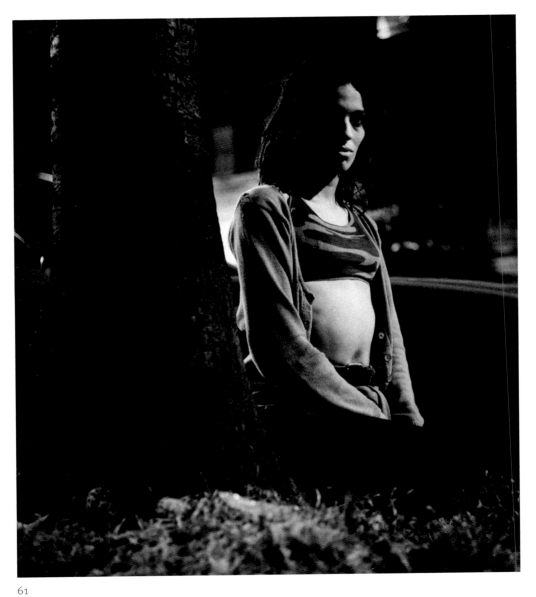

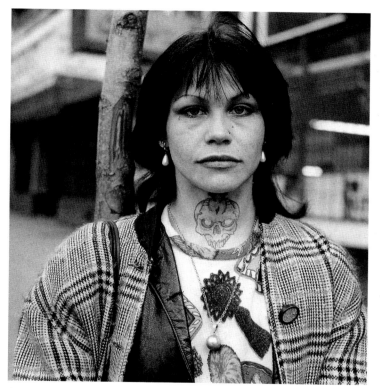

62

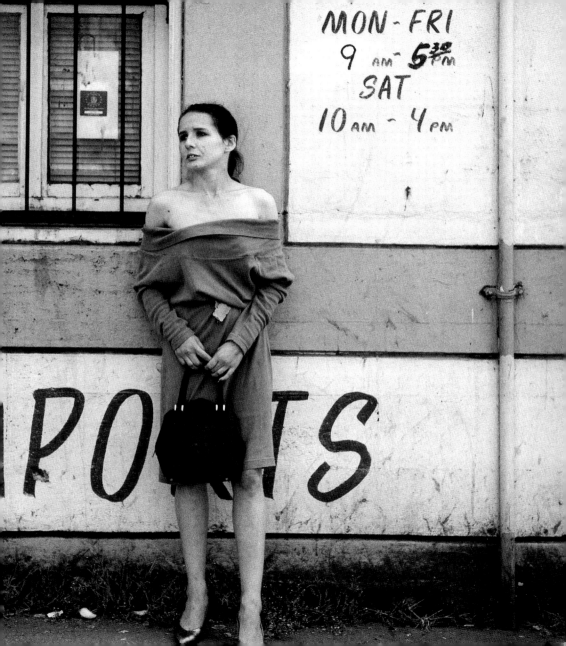

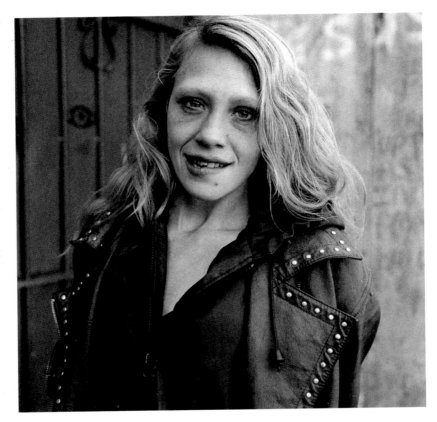

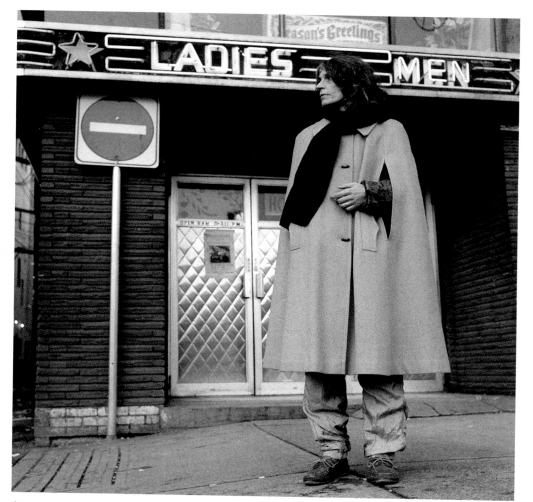

65

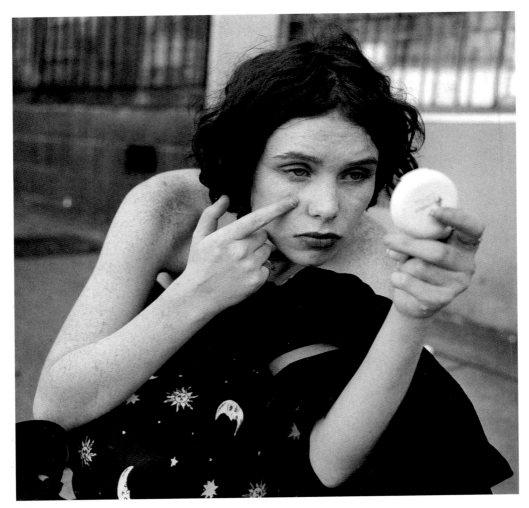

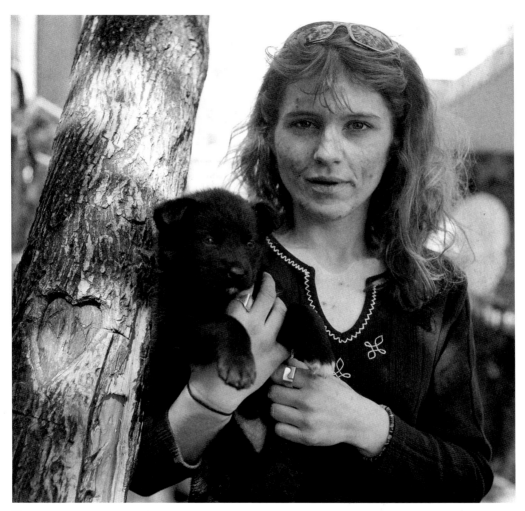

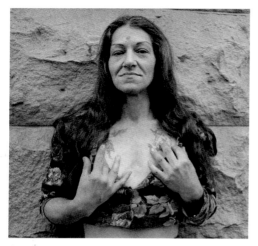

68

69

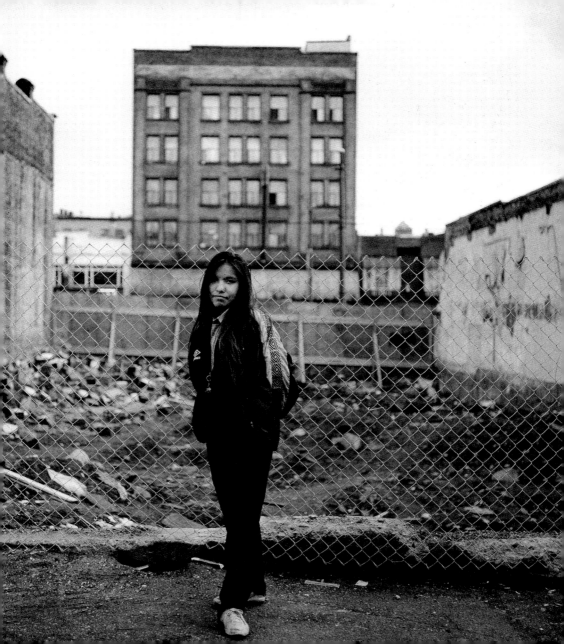

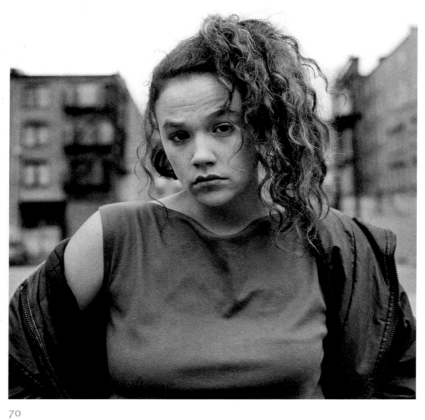

70

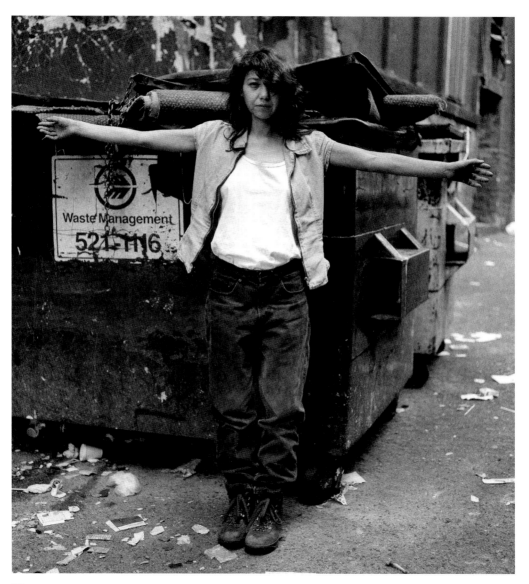

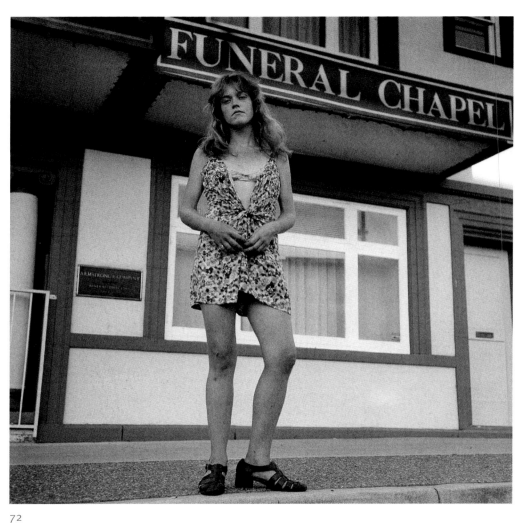

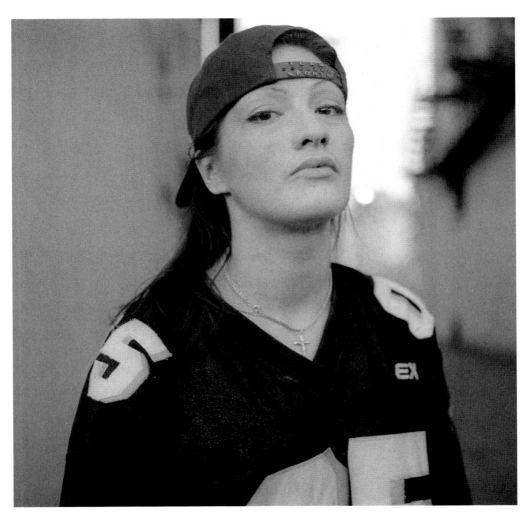

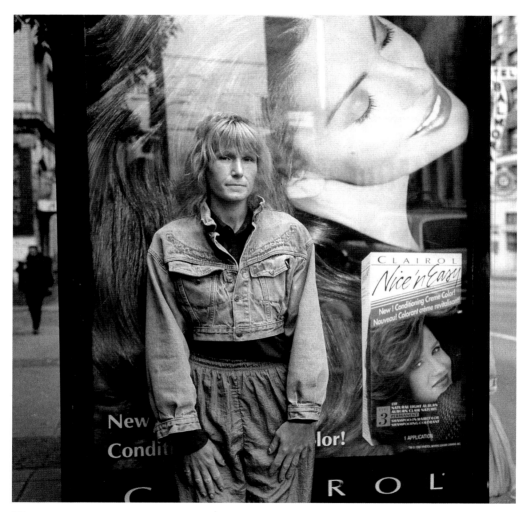

74

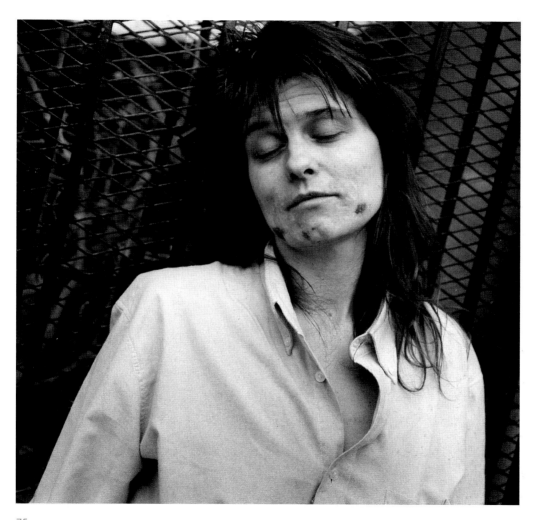

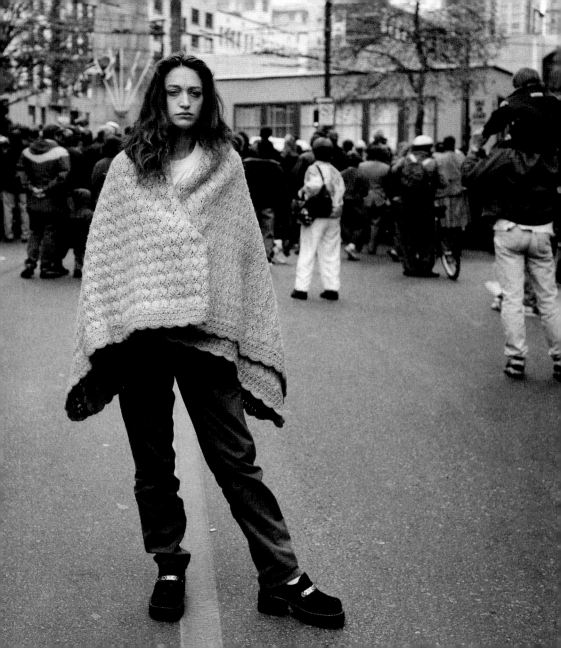

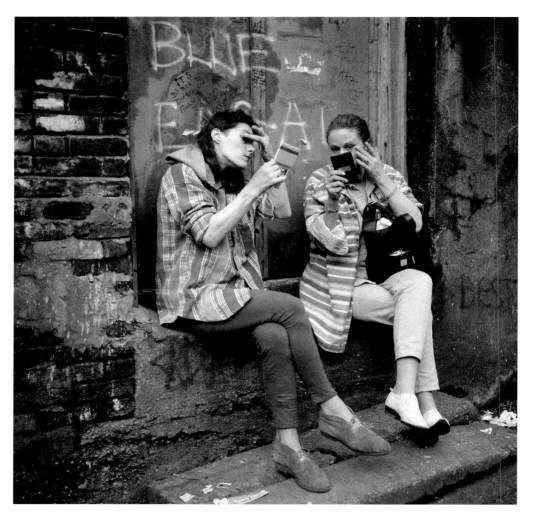

77

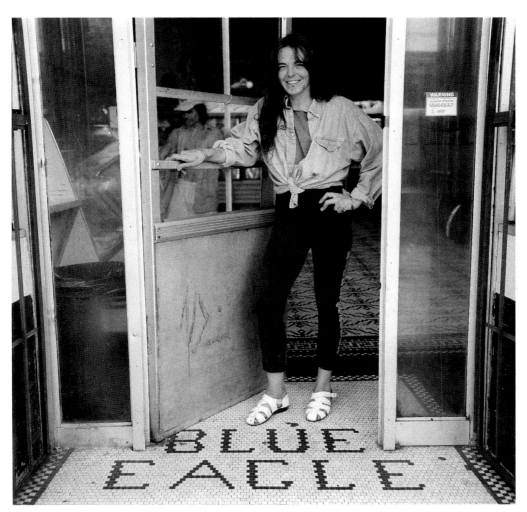

79

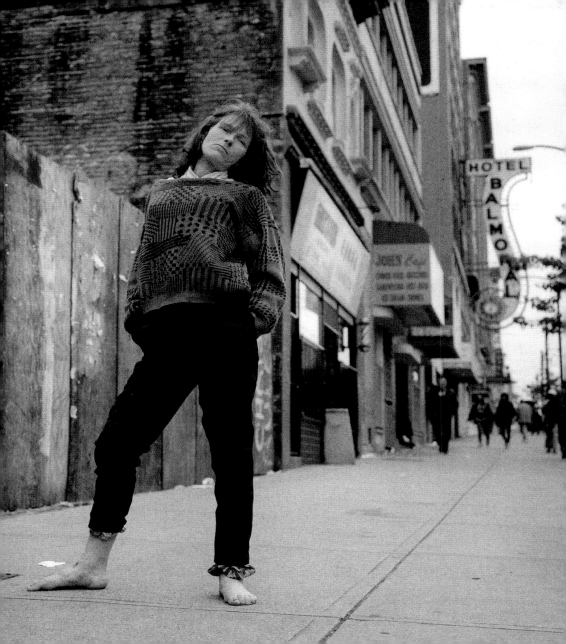

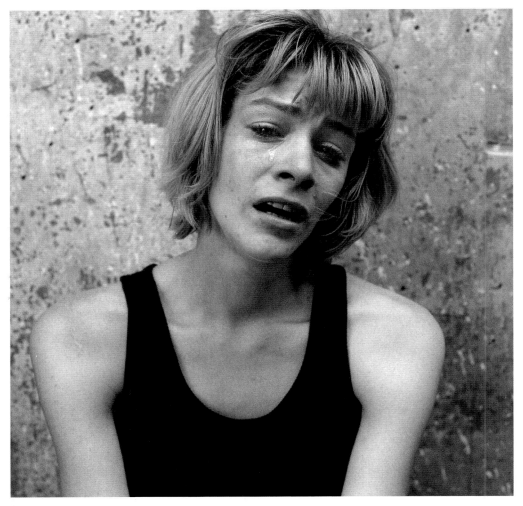

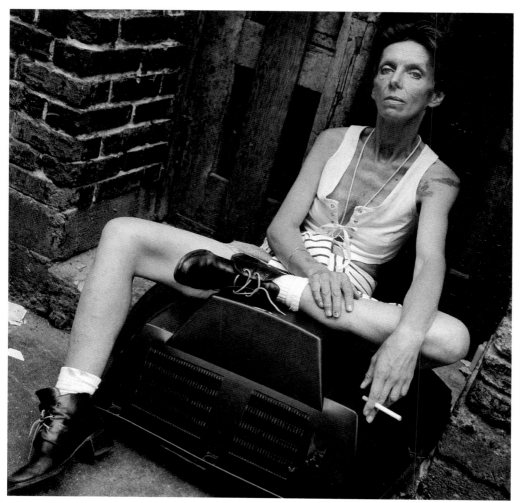

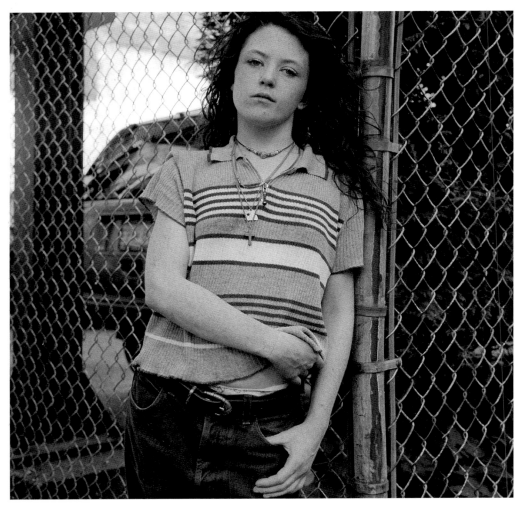

83

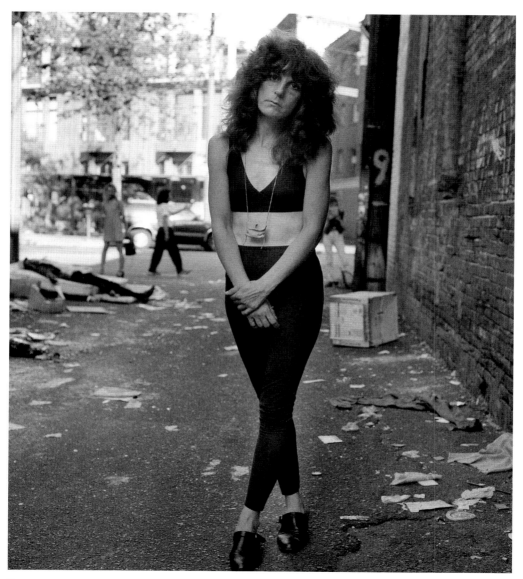

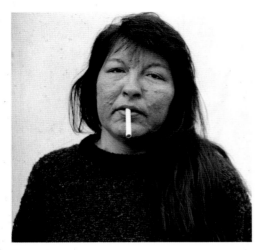

85

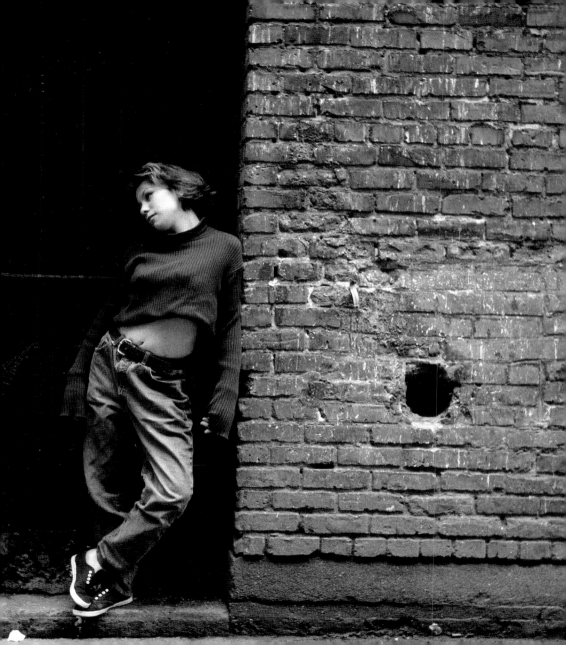

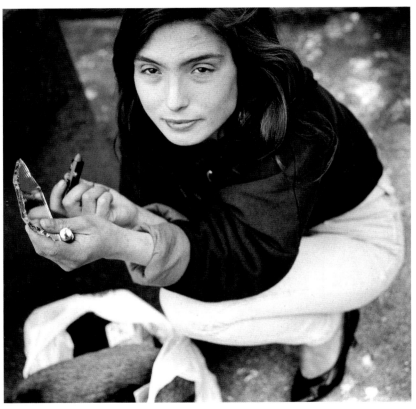

87

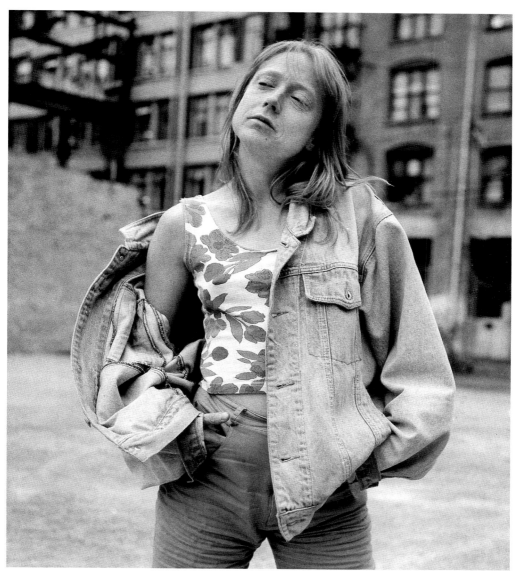

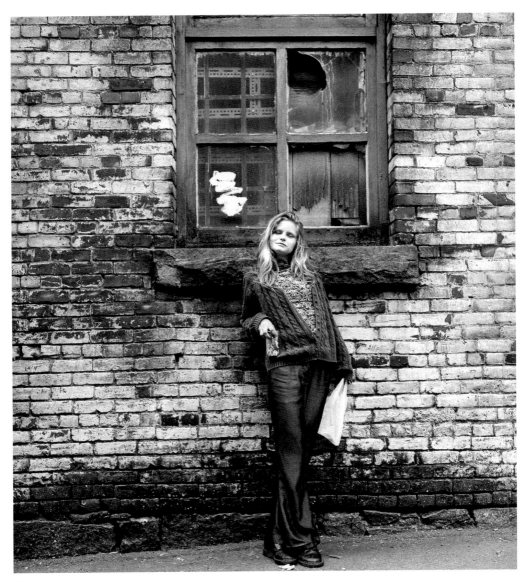

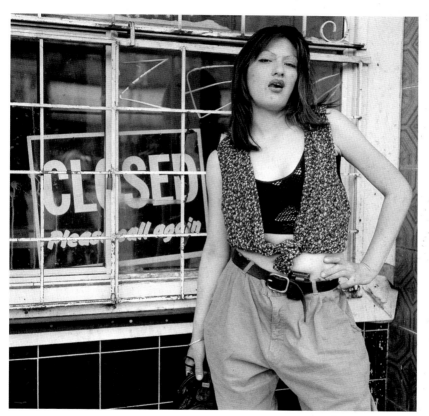

90

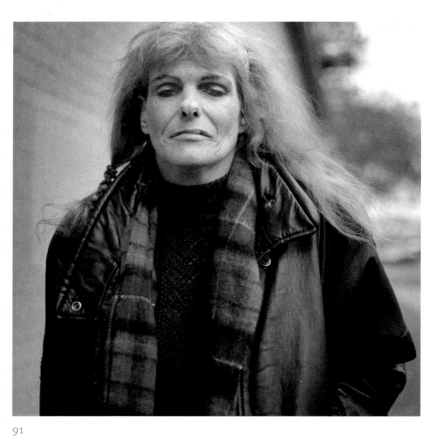

91

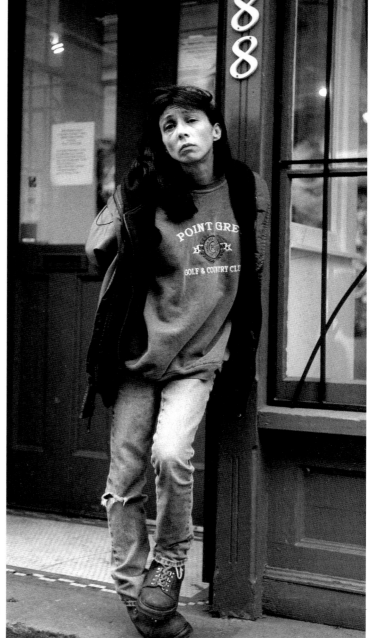

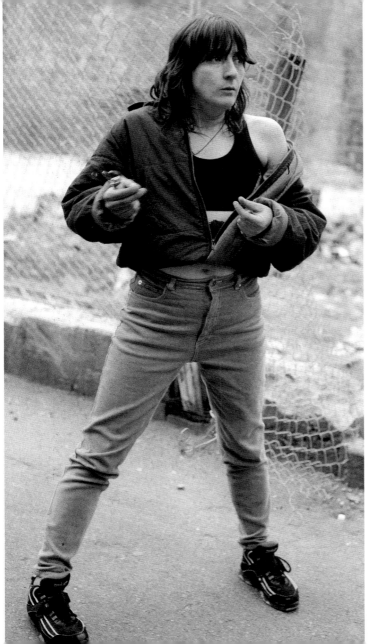

93

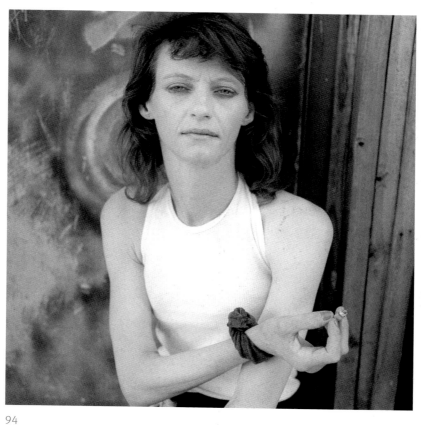

94

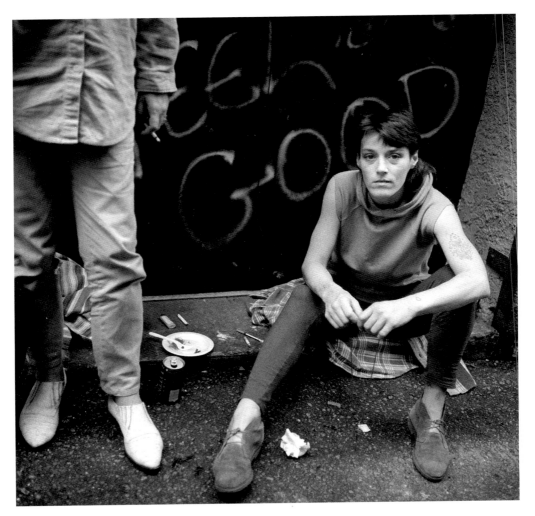

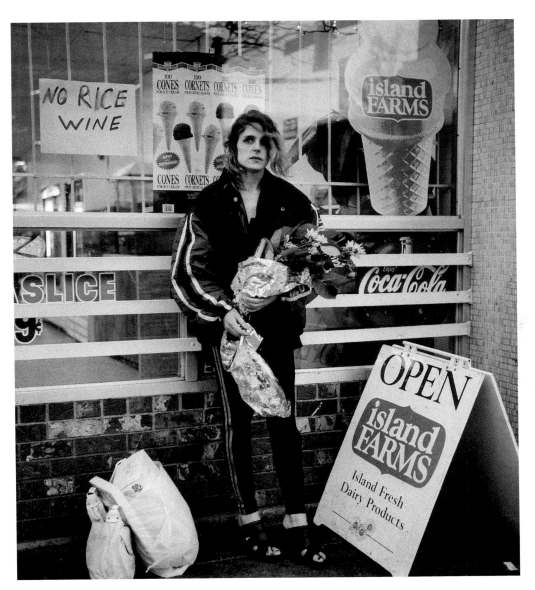

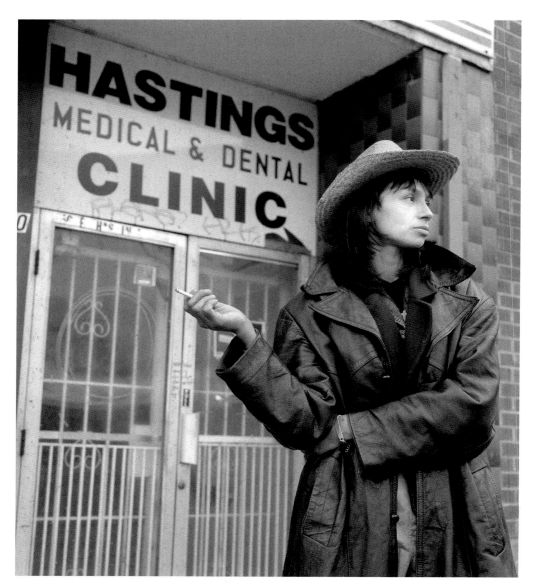

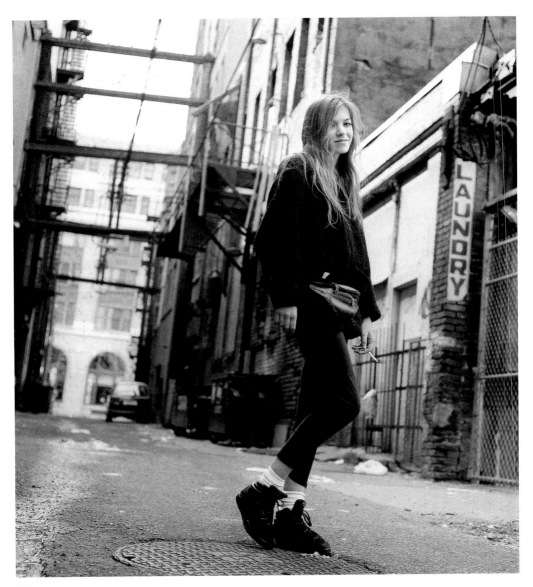

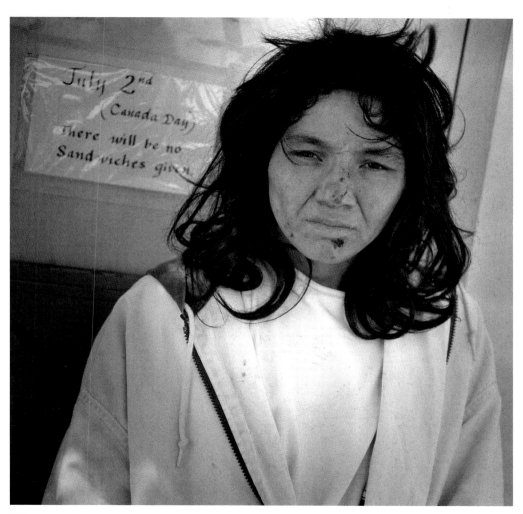

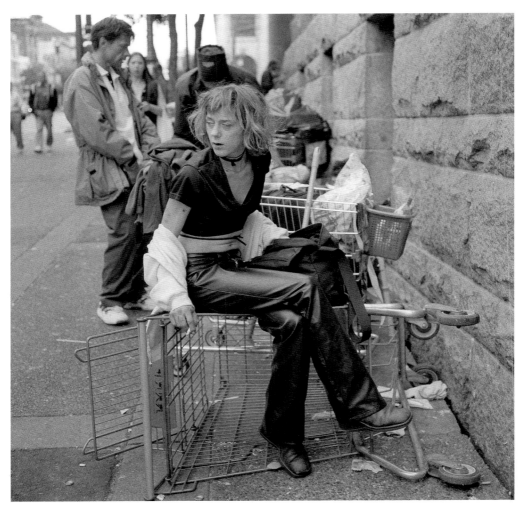

List of Photographs

Photo 025: August 9, 1998 | 103 East Hastings Street

Photo 026: April 26, 1998 | back door, old Bank of Nova Scotia

Photo 027: August 9, 1998 | Pigeon Park, West Hastings and Carrall Street

Photo 028: July 25, 1999 | New Zealand Rooms, 235 Main Street

Photo 029: April 26, 1998 | old Ferry Market, 117 East Hastings Street

Photo 030: September 20, 2000 | pawn shop, Columbia and Hastings Street

Photo 031: July 1, 2001 | old Smiling Buddha, 109 East Hastings Street

Photo 032: November 17, 1999 | Sunrise Market, 300 Powell Street

Photo 033: May 15, 2001 | Hotel Empress, 235 East Hastings Street

Photo 034: March 29, 1998 | back door, Loggers Club, 26 East Hastings Street

Photo 035: July 1, 2001 | Pantages Theatre, 144 East Hastings Street

Photo 036: January 12, 2001 | New World Hotel, 217 Dunlevy Avenue

Photo 037: September 20, 2000 | abandoned movie theatre, 108 East Hastings Street

Photo 038: February 28, 1999 | pawn shop, 58 East Hastings Street

Photo 039: May 10, 1998 | Chinatown alley, 53 East Pender Street

Photo 040: August 13, 1999 | alley, Orange Hall, Gore and Cordova Street

Photo 041: August 2, 1998 | Wings Cafe, 325 Carrall Street

Photo 042: August 9, 1998 | alley, 30 East Hastings Street

Photo 043: March 22, 1998 | alley, empty lot, 62 East Hastings Street

Photo 044: September 16, 2001 | gas station, 475 East Hastings Street

Photo 045: August 8, 1998 | Dunlevy Avenue and Cordova Street

Photo 046: August 2, 1998 | alley behind Gospel Mission, 325 Carrall Street

Photo 047: July 18, 1999 | alley, old bank, 92 East Hastings Street

Photo 048: September 13, 2000 | Chinatown alley, 115 East Pender Street

Photo 049: August 8, 1999 | Carnegie Centre, Main and East Hastings Street

Photo 050: April 11, 1999| old Lyric Theatre, 300 West Pender Street

Photo 051: May 3, 1998 | Brandiz Hotel, 122 East Hastings Street

Photo 052: July 26, 2000 | alley, Washington Hotel, 177 East Hastings Street

Photo 053: October 5, 2000 | Pigeon Park, Carrall and West Hastings Street

Photo 054: August 8, 1998 | Sisters of the Atonement, Dunlevy Avenue

Photo 055: October 17, 1999 | Oppenheimer Park, Dunlevy Avenue

Photo 056: March 7, 1999 | empty lot, 40 East Hastings Street

Photo 057: August 2, 1998 | alley, Brick Yard, 315 Carrall Street

Photo 058: October 4, 1998 | empty lot, 62 East Hastings Street

Photo 059: July 29, 2001 | alley behind pharmacy, 348 Powell Street

Photo 060: July 18, 1999 | Victory Square, Cambie and West Hastings Street

Photo 061: August 13, 1999 | Community Directions, 384 Main Street

Photo 062: May 17, 1998 | Blue Eagle Cafe, 130 East Hastings Street

Photo 063: May 3, 1998 | Cava Autobody, 124 East Cordova Street

Photo 064: September 13, 2000 | Chinatown alley, 83 East Pender Street

Photo 065: December 22, 1998 | Hotel Empress, 235 East Hastings Street

Photo 066: September 13, 2000 | Blue Eagle Cafe, 130 East Hastings Street

Photo 067: May 6, 2001 | Carnegie Centre, Main and East Hastings Street

Photo 068: October 4, 1998 | old Koret Building, 99 East Cordova Street

Photo 069: March 22, 1998 | empty lot, 117 East Hastings Street

Photo 070: November 11, 1998 | empty lot, 55 East Hastings Street

Photo 071: February 22, 1998 | alley, Brandiz Hotel, 122 East Hastings Street

Photo 072: August 8, 1998 | Armstrong Funeral Chapel, 304 Dunley Avenue

Photo 073: August 9, 2001 | alley, Patricia Hotel, 403 East Hastings Street

Photo 074: October 2, 1998 | bus stop, Main and East Hastings Street

Photo 075: February 14, 2000 | Ho Wah Hair Stylist, 123 East Hastings Street

Photo 076: November 11, 1998 | Victory Square, Cambie and West Hastings

Photo 077: February 22, 1998 | back door, Blue Eagle Cafe, 130 East Hastings Street

Photo 078: August 2, 1998 | Blue Eagle Cafe, 130 East Hastings Street

Photo 079: October 4, 1998 | old Koret Building, 99 East Cordova Street

Photo 080: April 26, 1998 | empty lot, 117 East Hastings Street

Photo 081: August 30, 1998 | alley, Army & Navy Dept. Store, 27 West Hastings Street

Photo 082: August 8, 1998 | back door, The Only Seafood, 20 East Hastings Street

Photo 083: July 17, 1998 | alley, Budget Car Rental, 99 West Pender Street

Photo 084: August 2, 1998 | alley, Wings Cafe, 325 Carrall Street

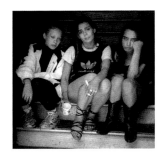

The Ethic of Photographs

KEN DIETRICH-CAMPBELL

"Although definitions of visuality vary from thinker to thinker, it is clear that ocularcentrism aroused (and continues in many quarters to arouse) a widely shared distrust. Bergson's critique of the spatialization of time, Bataille's celebration of the blinding sun and the acephalic body, Breton's ultimate disenchantment with the savage eye, Sartre's depiction of the sadomasochism of the 'look,' Merleau-Ponty's diminished faith in a new ontology of vision, Lacan's disparagement of the ego produced by the mirror stage, Althusser's appropriation of Lacan for a Marxist theory of ideology, Foucault's strictures against the medical gaze and panoptic surveillance, Debord's critique of the society of the spectacle, Barthes' linkage of photography and death, Metz's excoriation of the scopic regime of the cinema, Derrida's double reading of the specular tradition of philosophy and the white mythology, Irigaray's outrage at the privileging of the visual in patriarchy, Levinas' claim that ethics is thwarted by a visually based ontology, and Lyotard's identification of postmodernism with the sublime foreclosure of the visual..."

—Martin Jay,
Downcast Eyes: The Denigration of Vision in Twentieth-Century French Thought

Lincoln Clarkes first showed a series of forty *Heroines* as part of a solo exhibition entitled *Photographs* at the Helen Pitt Gallery in Vancouver during the summer of 1998.

Julia Shilander had balked at exhibiting her radically sexual paintings at the last minute, and although I had only seen one of the new photographs of heroin-using women on the streets of Vancouver's Downtown Eastside, I knew they would be powerful enough to replace Shilander's paintings in the gallery programme. What I didn't realize at the time is that they would seriously challenge established theories of art.

The series, as an art project, is a product of the day-to-day life of the artist. Clarkes has cycled through these streets as his neighbourhood for the past twenty years, to and from the cheap studio spaces and artist lofts in the derelict part of downtown. Clarkes' professional reputation comes mostly from photographing women and famous celebrities, although environmental landscapes and architectural degradation are also part of his practice.

Looking back, the *Heroines* series began in 1996 with a large, plastic laminated and grommetted print of a woman shooting up in a bus shelter in front of a Kate Moss "heroin chic" Calvin Klein ad, which first appeared at the Saints and Sinners 50/50 Benefit Show at the Pitt Gallery on Hastings Street. The piece was dated, signed, and hand-titled "Leah on Heroin." Significantly, the camera angle was determined by the necessity for Clarkes to use his body to block Leah's actions from the view of a police cruiser parked across the street.

A year later, the portraits took on a new look, as Clarkes' fidelity grew and the *Heroines* series became a passion. For the next five years Lincoln was there, in those streets and alleys, with a female assistant. A natural light portrait entitled "3 Darlings" epitomized the new, more intimate and more assured look of the *Heroines* portraits that were to follow. It featured three young, addicted women sitting on the steps of the Evergreen Hotel at nine in the morning. He first met Patricia Johnson, the woman on the left (who joined the list of missing women in 2001), and she introduced him to her two friends. Dated 1997, it was the first work one saw upon entering the gallery, and it set the tone for the rest of the series.

Clarkes takes his black and white photographs with a twin-lens Rolleiflex and prints them in 7½ x 7½ inch format on 8 x 10 paper, matted and mounted for exhibition in 16- x 20-inch frames. The viewer assumes an intimate, conversational distance, face to face with each photograph.

The series has grown from the forty portraits exhibited in *Photographs* to about four hundred today, and the controversy over their meaning continues. From being selected by Paula Gustafson, editor of *Artichoke* magazine, as "most memorable Vancouver visual art exhibition of 1998," and being the subject of an award-winning documentary film *(Heroines: A Photographic Obsession)* by Peace Arch Entertainment, to having a commemorative website shut down by detractors which resulted in threats of violence to the artist, the ongoing series has created its own ethical imperative, balancing political correctness with sexuality, much as the "heroin chic" billboard injects sexuality into consumerism, although "How does he get them to pose like that?" wouldn't likely be asked at a Calvin Klein fashion shoot.

There are many other significant moments in the history of the series, including an unplanned *Heroines* group portrait on Mother's Day, 1998. Clarkes had, for years, wanted to take a photograph in memory of the Montreal Massacre of fourteen women. That spring he found himself overwhelmed by women wanting their photographs taken. There were so many women waiting for him that morning in the alley between Chinatown and the Old Portland Hotel that the idea for a group portrait arose spontaneously. Even as he set up the shot, more women arrived. Only after printing the shot did he realize that the photograph he had been thinking about for so long had taken itself.

Our popular understanding of ethics is "a jumbled confusion of legalistic formalism, scandalized opinion, and theological mystification."[1] This confusion sets the scene for the controversy that has accompanied the public exhibitions of the *Heroines* portraits. People's responses to the *Photographs* show were so powerful that the media started covering the situation on the Downtown Eastside like never before. Prior to the showing of *Photographs* there was no such coverage of the troubled situation on Vancouver's skid road. The general consensus at the *Photographs* show was that "looking into their eyes" was a radical experience. "Giving faces to statistics," human respect, and the artist's intentions were called upon in the name of closure. So sensitive was the subject touched by the *Heroines* that the controversy generated internal divisions in all the forums where it took place, formally and informally, and extended from the academe to the gutter. Everyone had an opinion, if not a personal stake in the matter.

Photography is a creative act that mechanically reproduces itself. Whenever the content is another gaze, the politics of representation are involved. Representation of the

gaze of the Other may bode neither good nor evil, but does solve the problem of the reality of perception. The gaze as object does not exist, except as a psychical object of what Freud, for example, calls "reality testing," a preconscious faculty of the ego. One of the raisons-d'être of the reality principle is the attempt to refind something that has been irrevocably lost. In other words, the lack which is the cause of desire is the criterion of the desirability of objects. The opposition between subjective and objective didn't exist from the first. From an ethical point of view, the truth of an event is one's fidelity to it. This is the threshold of fantasy, and also of evental truth. Fidelity to the truth of the event is the real face of ethics, whether they be Kantian or Sadean.

In its Greek origins, ethics concerns the quest for a good "way of living." It is that part of philosophy which organizes practical existence around the Good. For the moderns, with Descarte and Kant, ethics becomes more like morality, which judges the practice of a Subject, whether it be individual or collective. Hegel introduces a distinction between ethics and morality. Morality is the principle of reflexive action, while ethics concerns "immediate firmness of decision."[2] Ethics concerns particular situations, singular processes, and the destiny of *truths*, in the plural. "An evental fidelity is a real break (both thought and practised) in the specific order within which the event took place (be it political, loving, artistic or scientific). I shall call a "truth" (*a* truth) the real process of a fidelity to an event: that which this fidelity *produces* in the situation."[3]

The Other doesn't exist. It is a register of the social link. There is no God. The One is not. We do not recognize, let alone respect, the Other. We recognize the Same. If there can be no respect for those who do not respect differences, "respect for difference" constitutes an identity, not an ethic.

The controversy, which attests to the *Heroines* as an evental break with reflexive art practice, revolves around the politics of representation. "I have a problem with them" turns into "You can't deny he got artistic capital out of them." It's not clear whether the problem here belongs to the artist or the viewer, or whether it matters. The critical perspective belongs to a Marxist-feminist school that borrowed the vocabulary of psychoanalysis and applied it to art theory. The influence of Martha Rosler on photography and Laura Mulvey on film was enormous in the field, and their analyses of social documentary and visual narrative still hold sway some twenty-five years later.

Rosler's 1974 conceptual art installation, *The Bowery: in two inadequate descriptive systems,* set the stage for the ethics of social documentary in art theory. Street shots,

straight on, mostly of storefronts, much like the backgrounds in the *Heroines* portraits, sans inhabitants, but with empty bottle evidence, combined with words about being drunk cut out of interviews and conversations, half nouns and adjectives, half adverbs and verbs. Although its photo and text "poetry of drunkenness" was profoundly politically correct and eminently suitable for publication, for Rosler, "social documentary" was only a tag used by dealers to capitalize on conceptual art.

The Subject of *The Bowery* exists in relation to the viewer much as the discourse between analyst and analysand exists in relation to the couch. In both cases, the Subject is not there to be seen, although their flesh and blood existence is necessary. Rosler's conceptual representation of the "indignity of speaking for others" is structurally similar to the injunction against suggestion in psychoanalysis, symbolized in the use of the couch. But it is equally clear that there are analyses in which the use of the couch is contraindicated, just as there are situations in which speaking for others does not constitute an indignity. "Social documentary" in the case of the *Heroines* is a tag used by critics to theorize the social link between Clarkes and his Subjects.

The ethics of *The Bowery* are not, however, and despite appearances, antithetical to *Heroines*. The object of Rosler's critique is exploitative social documentary, so she represents without representing a series of supposed subjects in order to make her point about documentary photography's inevitable fate in a capitalist consumer economy. Politically, it is extremely difficult to tell if a person is doing something purely out of self-interest or for the Good. Even for the person involved. The latter consideration is perhaps more to Rosler's point, in which case her critique is itself selfless, and more concerned with the Good than with social documentary. Here the ethics of *The Bowery* and of *Photographs* coincide.

Laura Mulvey, an American feminist film theorist, producer and director, raised the bar in art theory a few notches with her 1975 *Screen* magazine essay, "Visual Pleasure and Narrative Cinema." She structures her analysis around cinematic representations of love and sexuality, and the effects of spectatorship on psychopathology. Mulvey coined the term "male gaze" to reflect the split between active/male and passive/female positions vis-à-vis the "pleasure in looking." Her model is the Freudian theory of infantile scopophilia.

She takes what she perceives as a "controlling male gaze" and splits it between two modes of looking: voyeuristic and fetishistic. Already, despite the usage of its vocabu-

lary, we have left the field of psychoanalysis and entered a feminist deconstruction of masculinity, a masculinity defined on one hand as sadistic (in the popular sense) and on the other as overvaluing the female image.

If we follow Mulvey's thesis further, we find that the "controlling male gaze" is composed of three specifically male "looks:" the look of the camera as controlled by a man, the controlling look of a man at a woman in a film, and the look of the male spectator.

If we limit our own extemporizations on the experience of viewing the *Heroines* portrait series on exhibit in an art gallery to the three registers listed here, or worse yet, on Mulvey's presumption of a correlation between sadism and fetishism, we will not get much further than the argument from fashion photography—its aesthetic is shallow, therefore any art based on its techniques is shallow—which is another *post hoc ergo propter hoc* fallacy that might make for interesting conversation, but won't get you any closer to the meaning of the *Heroines* series.

Consciousness is an elision of the fact that not only does it look, it shows. In dreams, the emphasis is on "it shows." The gaze is the object by which I am surprised, insofar as it changes my perspective on the world. The gaze I encounter is not a seen gaze, but a gaze I imagine in the field of the Other.

> "...the satisfaction of a woman who knows she is being looked at, on condition that one does not show her that one knows that she knows."[4]

The *Heroines* series shows the familiarity that comes with/from uninterrupted dedication to an open-ended development of a style, the precariousness necessary to the becoming of the *Heroines* series, a record of involvement between photographer and subjects that a preplanned project could never achieve. And that's where their social, rather than personal, value lies. They subvert the modernist lament that you never see me in the place I look at you from, by producing a gaze from the same place, photographically, that you'd normally avoid looking at, and putting it in a place designed for viewing visual art.

In relation to fashion photography, the *Heroines* are the wrong subjects. However, the disjunction between technique and subject matter is not empty. It's full, instead, with ethical significance, arising from the combination of attention and respect that brought the series into being. This isn't about using heroin addicts as fashion models. If it weren't for a professional artist developing a committed relationship with the suf-

fering women he had seen so many of, the *Heroines* series wouldn't exist. And who could have known how these photographs would pump up the level of how people were talking about these women already?

You really have to live in a fashion-centred city like London or Paris to see how fashion can be a fundamental category of human interrelations, how it can consume everything we do in relation to each other.

Coco Chanel said that fashion is designed to become unfashionable. Fashion reflects enjoying oneself now, originally, personally, and so, in a sense, in opposition to what has been before, including oneself.

Although semiotically a monster, all the more tied to convention the more it designs its enjoyment, the fashionista makes the distinction between nostalgia and invention irrelevant. There is always a new balance to be obtained between the two. And the clashes between houses feed the frenzy that has culminated in heroin and dumpster chic. Streetstyle rules.

The work of Martha Rosler and Laura Mulvey was important for its time and indeed an essential development in early '70s feminist art theory. But by the early '90s such analysis had become passé and mired in academic discourse. What Mulvey produced was not a psychoanalysis of spectatorship, but a critique of the myth of feminine masochism, which, if it weren't for some women's complicity, would be seen for what it really is, a masculine fantasy. To speculate on Clarkes' motivations through this filter is to miss the point of his photographs entirely.

Martha Rosler produced an ethics of representation, not just a conceptualist work of art. When in doubt about the transparency of one's motives, don't get involved in speaking for others. Unfortunately, motives are always obscure.

WORKS CITED:
1. Badiou, Alain. *Ethics: an Essay on the Understanding of Evil*, Verso: London, 2001.
2. Ibid.
3. Jay, Martin. *Downcast Eyes: The Denigration of Vision in Twentieth-Century French Thought*, University of California Press: Berkeley, 1994.
4. Lacan, Jacques. *The Four Fundamental Concepts of Psychoanalysis*, W.W. Norton: New York and London, 1978.
5. Laplanche, Jean and Pontalis, Jean-Bertrand. *The Language of Psycho-Analysis*, W.W. Norton: New York and London, 1973.
6. Mulvey, Laura. "Visual Pleasure and Narrative Cinema," *Screen* magazine, 16(4), 1975.
7. Rosler, Martha. *The Bowery: in two inadequate descriptive systems*; [art installation].

Photographer As Witness

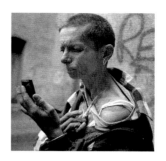

PATRICIA CANNING

Historically, the purpose of social documentary photographs has been to shock, dismay, and provoke action, to change the conditions that create poverty and suffering. In the early 20th century, American social reformer Lewis Hine used the medium of photography as a tool to illustrate the living conditions of the urban industrial working class. Hine portrayed the human misery created by social conditions so appalling that viewers were moved to call for immediate political remediation. The work of crusader Jacob Riis documenting conditions of children working in textile industry sweat shops is credited with achieving significant reform of child labour laws in the United States.

In the 1930s the New York Worker's Photo League adopted the idea that photographs could bring about political reform and social change through public awareness of the lives of the dispossessed and disadvantaged. To the Photo League, photography was a weapon in the class struggle. The photographers of the League saw it as their responsibility to train photographers to document that struggle, and to report the evidence through the public exhibition of those photographs. One of the League's first shows, a collaborative exhibition directed by Aaron Siskind, featured a description of the Bowery, an immigrant neighbourhood on the lower eastside of New York City. Magazine editors of the day easily transferred the pictorial convention developed by the League photographers—showing groups of pictures carefully arranged in a sequence to convey a particular social analysis—to the print medium soon after the League perfected the style.

The graphic appeal of gritty reality coupled with compositional elegance was quickly adapted as the norm by mass circulation publications to dramatically interpret every aspect of the modern world to their audiences.

Newspapers summarized entire subcultures and movements of social change by featuring a single, captivating photographic image. Although the notorious press shot by photographer Arthur Fellig, aka Weegee, of the gangster's corpse on the New York sidewalk was made with a different intention than that of Manuel Alvarez Bravo's picture of the murdered striking worker on a Mexico street, both images are early examples of the photographer bearing witness to human tragedy. The Weegee view was rooted in his fascination with violence, hysteria, and shabby street crime. He was the maker of the news photograph, which functioned as a record of events, not an interpretation of social reality. The role of the news photographer as detached professional observer, one who pictures experience without explaining its meaning, has been sustained in media representation since the early days of photojournalism. This tradition continues into the present with our current digital capturing of images for the print media. Canadian photojournalist Nick Didlick, among the first on the scene of the Lockerbie air crash in 1988 for Reuters News Agency, has recounted the discipline he exerted to keep his emotions in check as he walked the crash site, conveying only the facts of body parts strewn among the wreckage. In Didlick's terms, maintaining the objective viewpoint in the face of such human tragedy is the working standard of a contemporary news media photographer.

Like earlier League photographers, *Life* magazine photojournalists—Eugene Smith in particular—were masterful at assembling images into a narrative chain to create a photographic essay with a persuasive thesis. Like Jacob Riis and Lewis Hine, Smith was driven by a belief that knowledge provoked action and photography was an effective instrument for initiating social change. However, unlike the press photographers, Smith believed the persuasiveness of his images was a result of passionate engagement with his subject. In his last book, *Minamata*, the Japanese fishing community where he lived and photographed the consequences of mercury poisoning, he stated, "the first word I would like to remove from the folklore of journalism is the word *objective*." *Minamata* is a virtuoso documentation of courage, of people struggling to overcome the intergenerational impact of power and greed on their community. Smith employed all the pictorial techniques we have come to associate with the photojournalism genre: bold composition, a clear centre of interest in a full frame, depth,

energy, and tension in prints which have a tonal range from whitest white to blackest black. The message of *Minamata* is unavoidably clear: here live heroes. Smith's documentation enshrined the heroic in ordinary life.

In Canada, John Grierson, founding Commissioner of the National Film Board of Canada, first enunciated the principled stance of the social utility of images, and indeed the fact of documentation itself. Grierson, who coined the word "documentary" in 1925, envisioned a film constructed with the intention to persuade, to motivate, and to act as a catalyst for change. A specialist on the psychology of war propaganda, he headed the department of mass media for UNESCO, and was critical to the development of Canadian photography practice. All Canadian photographers of significance undertook projects commissioned by the Stills Division of the National Film Board at sometime in their working careers until its collection was transferred to the Canadian Museum of Contemporary Photography.

Two photographers, both immigrants, quietly entrenched the humanist point of view in the practice of photojournalism in Canada. Kryn Taconis, a Dutch photographer who provided the eyewitness evidence of the retreating Nazi army massacre of citizens in Amsterdam's Dam square, was among the founders of the famous Paris photography cooperative, Magnum. After Magnum refused to use his images of an insurrection in Algeria, Taconis came to Canada and worked as a photojournalist documenting life in Canada for magazines of the post-war period. For over two decades, Taconis and Sam Tata, an immigrant from Shanghai in 1956 who documented Mao Tse Tung's revolution, described Canada to Canadians in regular contributions to all major magazines and newspaper colour supplements. Throughout the 1950s and much of the 1960s, their photographs told Canadians what their country and its citizenry looked like. Unlike the edgy outsider perspective of Robert Frank, whose corrosive depiction of Americans generated outrage and incomprehension, the social landscape of Tata and Taconis was largely orderly, peaceful, and purposeful. Canadians saw these images—and before television little else—and believed their point of view to be true.

Gene Smith was the role model for Tamio Wakayama, a journalist from Chatham, Ontario who had been raised in an internment camp in British Columbia. Wakayama joined the American civil rights movement as a field photographer for the Student Non-Violent Coordinating Committee (SNCC) in Mississippi. His work was encouraged

by Smith and supported by Jim Hughes, editor of the international journal *Camera 35*. Wakayama's first book, *Signs of Life,* also included images of life on Saskatchewan Indian reserves, in Doukhobor communities of the Kootenays, and Canada's significant experiment in higher education, the Rochdale College. These photographs are the only systematic report left of the Student Union for Peace Action that took ideas of social justice into depressed Canadian communities. Wakayama's social landscape is the short principled life of SUPA activists from 1964 to 1967, together with the organizers of the Company of Young Canadians in their early years of forming the Canadian practice model of urban community development in our inner cities. For the next twenty-five years, Wakayama documented the achievement of social justice by the Japanese Canadians in their struggle for redress and reparation and assertion of cultural identity and place.

"Beneath the Malebolge lies Hastings street
The province of the pimp...
where chancres blossom like the rose...
and mountains gaze in absolute contempt...
this is Canada."

Thus reads Malcolm Lowry's description of Vancouver's Skid Road in 1946 from its centre, then as now, the Carnegie Library at the corner of Main and Hastings. With the rise of another generation of social activism, which found its way to Vancouver by the 1970s, this historic neighbourhood, populated by the derelict and the abandoned workers of a resource extraction economy, was deemed an inner city community and renamed the "Downtown Eastside."

Lynn Phipps, a large format portrait photographer, came to the neighbourhood when it was still called Skid Road. Her task was to document the need for financing public sector housing for the indigenous population of Vancouver's inner city. Her photographs of the men, former seamen, loggers, miners, and railroaders—almost all war veterans now living in single room occupancy hotels—were used by the federal Central Mortgage and Housing Corporation as proof of the efficacy of experimental program initiatives in inner city urban housing. In the 1970s, government agencies throughout Canada routinely employed the use of the photojournalism style in offi-

cial publications and annual reports to promote their expanding social agendas. And with the collapse of the market across the country for extended magazine essays as a result of television competition, Canadian photographers obliged by providing illustrative realism for the public record.

Bob Semeniuk, a photojournalist on assignment in 1989 to illustrate an article on the growing numbers of urban youth being drawn into the life of the street, overturned the conventional subject/photographer relationship by putting the camera into the hands of ten young people who lived by their wits in Vancouver's Downtown Eastside neighbourhood. The photographs that resulted from this project, said: I was there; I did this; I saw this; I am.

At a Vancouver Museum symposium in 1993, a panel of photojournalists described the outcome of their professional impulse to work for social justice in quite different contexts: as social realist portraiture, factual depiction, investigative expose, and measured reconstruction of turmoil in civil society. All were very clear in their agreement about the use of their photographs as a tool to promote change in the ideological mode of John Grierson. One panellist described the experience of shooting film stills of the drug trade in Vancouver's east end as more harrowing than photographing the civil war in Somalia.

There have been few great works of photography depicting the life of women who work as prostitutes. Bellocq's portraits of prostitutes in turn-of-the-century New Orleans are a personal record unlikely to have seen the light of day if the glass plates had not been rescued and published by Lee Friedlander some sixty years later. The Hungarian photographer, Brassai, fascinated with the life that came out after dark, assiduously recorded the women and patrons of Paris brothels in *Paris de nuit*. However, it was Mary Ellen Mark in her 1981 extended colour photo essay about Bombay prostitutes—with whom she lived—who documented the realities and living conditions of these women with an honesty that is unencumbered, and almost singular in its accomplishment. Her example of treating prostitution as significant subject matter, and without emotional embellishment, gives their social landscape a quality of authenticity that could lead to the use of these photographs as evidence—these women lived and their lives have value.

Most attempts to depict the lives of women addicts in the Downtown Eastside of Vancouver have not been successful. The urban squalor of poverty can be seductively

picturesque, and photographing the social landscape of sex trade workers requires a sustained effort to avoid being furtive and voyeuristic. These days, an editorial photo assignment for the few magazines left in Canada that publish them is usually no more than a day shoot. In the twenty-first century, the practice of photojournalism, like the power of information to persuade, has diminished and mutated. Why do the photographs of Lincoln Clarkes in the collection *Heroines* succeed where most other efforts, all presumably sincere, have failed?

Lincoln Clarkes made more than four hundred portraits over a period of five years with the agreement and cooperation of the subjects. The *Heroines* portraits are made with a Rolleiflex camera, normally used for studio work, in available light, and printed rather low in contrast. The compositions are symmetrical and mainly frontal, and although a few of the women are smiling, most pictured here look at us quietly, even quizzically. Energy and tension are not evident in the consistently steady editorial approach that Clarkes used to make the *Heroines* photographs. In the *Heroines* work, the desperate urgency of the street hustle is absent. The pimps and drug dealers are invisible. Clarkes has inserted little of his personal style into these pictures and his autographic quality is limited to the conventions of fashion photography, where the clothes provide the surface details. These portraits are not dramatically expressive or deliberately emphatic, and yet, the impact of the *Heroines* portfolio on the viewer has been described as being suddenly struck. When we look at the *Heroines* images we are looking at the character of a life set within the character of a place.

The *Heroines* portraits are intimate photographs of women who have a high degree of comfort with the photographer. A few bare facts are presented with extreme emotional reserve. Women are identified here only by the date and location where the portrait was made; no other biographical information is volunteered. The images do include some place-identifying environmental details in signage and architecture, but any one of these women could be living in any North American or European city where there is no weather in the filthy streets. But where documentary photographs are typically taken for the purpose of affecting public persuasion, in the *Heroines* portraits Clarkes undertakes no responsibility for the reality, only for the pictures. He does not state his conclusion about the facts of the lives he photographs. A woman may be shown undergoing social forces that shape her life—the poverty, addiction, and sickness—but the photographer does not suggest ways she might deal with the facts. In *Heroines*, the photographer is fundamentally a kind stranger who makes no

judgement about the women he pictures. Clarkes' editorial duty to his material stops with the honest report.

The photographs of *Heroines* are made in the broad humanist point of view of the compassionate observer. Each portrait presents a picture of a woman as an individual coping with the deprivation of her day-to-day existence and addiction in an indifferent slum space. Taken altogether, the *Heroines* portraits are a social document of a life, of lives in pictures in one inner city neighbourhood in Canada. The images of these women living in the Downtown Eastside of Vancouver are important for their human value and unembellished depiction of what we prefer to repress and refuse to engage. In the nuances of restraint these photographs convey the face of survival in all its pity, fear, and small graces. In the *Heroines* portraits we also see that sometimes photography as an art can offer hope in a world of suffering.

"Huddled in an alley near Hastings and Carrall, [she] held a needle to her neck and blessed the drug that opened the door that allowed such angels in."

—Bill Richardson, "A Winter's Tale"

REFERENCES:

Bellocq, Ernest James. *E.J.Bellocq: Storyville Portraits*. Introduction by Lee Fiedlander John Szarkowski, editor. New York: Museum of Modern Art, 1970.

Brassai, [Gyula Halasz]. *Paris de nuit*. Paris: Gallimard, 1933.

Carey, Brian. *Kryn Taconis: photojournalist = photojournaliste*. Ottawa: National Archives of Canada, 1989.

Dessureault, Pierre. *Sam Tata: The Tata Era / L'Époque Tata*. Ottawa: The Canadian Museum of Contemporary Photography, 1989.

Eastman House. *Towards a Social Landscape*. Nathan Lyons, editor. New York: New Horizon Press, 1967.

Frank, Robert. *The Americans*. Introduction by Jack Kerouac. Millerton, New York: Aperture, Inc., 1959.

Grierson on Documentary. Edited by Forsyth Hardy. London: Collins, 1946. p.79.

Hine, Lewis W. "Social Photography, How the Camera May Help in the Social Uplift." In *Classic Essays in Photography*. Edited by Alan Trachtenberg. New Haven, Connecticut: Lietis Island Books, 1980.

Hine, Lewis W. and Gutman, Judith Mara. Lewis W. Hine, *1874-1940:Two Perspectives*. New York: Viking Press, 1974. International Center of Photography Library of Photographers, vol. 4.

Japanese Canadian Centennial Project Committee. *The Japanese Canadians, 1877-1977: A Dream of Riches/Un Reve de Richesses: Les Japonais au Canada 1877-1977*. Toronto, Dreadnaught Press, 1978.

Mark, Mary Ellen. *Falkland Road*. New York: Knopf, 1981.

Riis, Jacob. *How the Other Half Lives, 1901*. New York: Dover Publications, 1971.

Smith, W. Eugene and Smith, Aileen M. *Minamata*. New York: Holt, Rinehart, and Winston, 1975.

Wakayama, Tamio. *Signs of Life*. Toronto: Coach House Press, 1969.

Lowry, Malcolm. "Untitled." Kathleen Scherf, editor. *The Collected Poetry of Malcolm Lowry*. Vancouver: University of British Columbia Press, 1992. Poem no. 178.2, p. 159.

Bravo, Manuel Alvarez. Striking Worker Murdered [photograph]. 1934. In del Conde, Teresa, author. *Mucho Sol/ Manuel Alvarez Bravo*. Mexico: Fondo de Cultura Economica, 1989.

Weegee (Arthur H. Fellig). Murder at the Feast of San Gennaro [photograph]. 22 Sept 1939. In Weegee, Arthur F. *Naked City*. New York: Da Capo Press, 1988.

Richardson, Bill. "A Winter's Tale." *The Georgia Straight*. Vancouver, 21-28 Dec, 2000. Volume 34, #1722, p. 18.

Wood, Daniel. "Vancouver's Missing Prostitutes." Chick Rice, photographer. *Elm Street Magazine*. Toronto, November 1999.

In/Exclusion A Community Forum on Cultural Diversity in the Visual Arts [symposium programme]. Vancouver: Vancouver Museum Association, 8 Aug 1992. Collection: Patricia Canning, Convener. "The Photographer As Witness" [panel] Peter Bennett; Nick Didlick; Colleen Leung; Robert Semeniuk; Ulli Steltzer.

Through A Blue Lens [motion picture]. Directed by Veronica Alice Mannix and produced by Gillian Darling Kovanic and Graydon McCrea. Still photography by Robert Semeniuk. Vancouver: Odd Squad Productions Society, 1999. Distributed by the National Film Board of Canada.

McMillan, Stacey, et al (seventeen others from Downtown Eastside Youth Action Society); Semeniuk, Robert, compiler. *An Experiment in Power Pictures* [photographs]. Vancouver, DEYAS centre. Exhibited 1 November-15 November 1991 at Carnegie Library, Vancouver.

Phipps, Lynn. *Just Like You and Me* [photographs]. 1975. Vancouver, University of British Columbia, Main Library, Special Collections. Exhibited 11 Sept-4 Oct 1975, Fine Arts Gallery, UBC.

Siskind, Aaron. *Dead End: The Bowery* [photographs]. 1937. New York, The Photo League. Prior to 1935 it was called the New York Worker's Photo League.

Ministry of the Attorney General of British Columbia. *Annual Report of the Attorney General of British Columbia*, Victoria, 1974. Tamio Wakayama photographs, front and back cover.

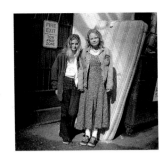

Around Here

ELAINE ALLAN

In the spring of 1998 I began volunteering at a drop-in centre for women in the sex trade on Vancouver's Downtown Eastside. One afternoon I discovered a stack of *Heroines* photographs in the bottom of a drawer. Among them was a portrait of Sheila Egan, a woman known by some of the clients who frequented the centre. Unfortunately, by the time I found the photos, Egan had been identified as one of the many "missing women" from the area. I never met Sheila, but as a result of having her picture around the centre I came to feel as though I knew her. Sheila's photograph inspired a lot of discussion at the centre; she had been well liked in the neighbourhood, and the women appreciated the opportunity to remember her. Soon her portrait was displayed on a corkboard, and if anyone moved the portrait one of the women would ask me where it had gone. One night a client wanted to take the photograph home with her. The two women had been close friends, and now that Sheila was missing and presumed dead, that photograph was the only "piece of Sheila" she had left.

Women who frequented the centre spoke often about Lincoln Clarkes and his photography. I used to think the *Heroines* photographs were powerful because I knew so many of the women in the pictures. Later, I realized Lincoln's photographs also had a profound effect on his subjects.

The women on the Downtown Eastside tend to be quite sentimental. Often estranged from family and friends, they cling to photographs as one of their last remaining ties. Some of them wear photographs close to their bodies, using plastic bags as protective

casings. Usually the photos are of children, or themselves, and serve as important mementos while surviving on the streets. One year, during the Christmas holidays, a client who had received her portrait from Lincoln asked me to take her to the police station. She had an outstanding warrant for her arrest, and wanted to turn herself in. Upon viewing her photograph she decided she wanted to get off the streets and would need to be admitted into a treatment facility. Her outstanding warrant was the only thing that would make admittance into detox impossible—the only thing standing in her way. She reasoned if she could deal with her charges that night, she might be able to begin treatment before the start of the new year. I took her to the police station and was able to visit her months later in a Port Coquitlam treatment centre. She still had Lincoln's photograph with her; it was tacked up on a board beside her bed at the recovery house. The portrait had served as a catalyst for her to deal with her drug addiction and to finally get off the streets.

Several months after volunteering I became a paid employee of the drop-in centre. Being a non-profit agency in one of Canada's poorest neighbourhoods, the centre operated on a minuscule budget. Each night we fed upwards of seventy-five women on an allowance of about twenty-six dollars, the food supplies supplemented by donations from the local Food Bank. Yet, each week, the centre delivered on its mandate to provide meals and showers for desperate, hungry women. The drop-in program was started by a handful of people in the early 1980s and provided coffee, donuts, and temporary shelter for women in the sex trade. When I arrived on the scene, the organization had been funded and operated by a collaborative team of Anglican and United Churches for almost sixteen years. This small, but highly functional program was volunteer-driven, which enabled it to continue operating with minimal funding. Two paid staff members worked alternate nights and crews of dedicated volunteers cooked the meals and helped run the centre.

In a city otherwise known for having one of the highest standards of living in the world, it is difficult to fully grasp the enormity of Vancouver's drug problem. A 1992 comparative national study from the Canadian Centre on Substance Abuse cited British Columbia as having the country's highest per capita illicit-drug-related costs. Direct law enforcement costs alone that year were in excess of $57 million.[1] The number of needles distributed in Vancouver had jumped from an average of 350 per day in 1989 to almost 3.5 million needles annually by the year 2000. During the 1990s, Vancouver had the highest HIV infection rate in the developed world. Today, the

Downtown Eastside is considered by city planners to be one of its toughest challenges. Three tiers of Canadian government have poured money into the area over the course of decades, hoping the social ills of this neighbourhood would simply disappear. Past governments paid little attention to how public money designated for the Downtown Eastside was administered—creating a legacy of poverty, crime and human suffering, all fueled by the out-of-control drug industry.

Public awareness of the issues affecting the Downtown Eastside grew as images from the neighbourhood started showing up in the media. It appeared that no one—from Parliament Hill to the boardrooms of Howe Street—had any idea just how bad things had gotten on Vancouver's mean streets. In 1998, one year after Lincoln Clarkes began shooting his *Heroines* series, Vancouver recorded 416 deaths to illicit drug overdoses—against the backdrop of rising welfare costs, epidemic illness, and increasing levels of violent crime. Turf wars began over who controlled Hastings Street among various social agencies on the strip. Both in the media and behind the scenes, the non-profit organizations that had dominated the Downtown Eastside scene were lashing out at each other in an attempt to quash any contenders who were in a position to bid for the lucrative public money or challenge them on their operating practices. Many praised Clarkes for bringing the plight of the women of the Downtown Eastside into public focus; others called his work exploitative. As public awareness increased, the credibility of the agencies and individuals who had for decades claimed to be "experts" came under harsh scrutiny. The public wanted to know who was in charge of the Downtown Eastside and demanded to know why they hadn't been better informed of the crisis.

Lincoln Clarkes' *Heroines* series helped give a human face to the women of this troubled district and incited both dialogue and controversy in its wake. The growing public concern around issues facing the Downtown Eastside has significantly altered the playing field of the area, as well as that of city council. Today politicians and the public alike are ardently involved in the process of rebuilding and revitalizing this historic and vibrant neighbourhood.

In the *Heroines* series Clarkes strives to present the women as they are, usually photographing them no more than a few feet from where he has met them. The backdrops are a blunt depiction of an inner-city landscape in decay, an area in urgent need of sensitive renewal and restoration. Without question, Lincoln Clarkes' photography

has served to promote public compassion and positive action for a sector of women that our society had thought of as "disposable" or simply lost. The faces that stare back at us from the portraits remind us that they are more than just statistics, that they are women worthy of our attention and our gaze.

1. MacPherson, Donald. *A Framework for Action Draft Discussion Paper,* Drug Policy Coordinator, November 21, 2000.

Vancouver's Downtown Eastside: Statistics

POPULATION

In 1996 the Downtown Eastside had a population of 16,275 people with women accounting for only 37% of the residents. Forty percent of the overall population were between 20 and 45 years of age and 11% were under the age of twenty. The median income was approximately $10,000 per annum, placing 68% of the Downtown Eastside's residents in the "lowest income" bracket for Canadians.

HOUSING

Many residents of the Downtown Eastside live in single room occupancy hotel rooms (SROs). Most landlords cater to the maximum allowable rent payable by provincial welfare and charge $325 a month per SRO. The SROs are notorious for being small (some rooms 10' x 10' or smaller) and many are infested with cockroaches, bedbugs and mice. Typically these hotels offer little in the way of security. Most SROs are set up for residents to share communal showers and bathrooms and don't come equipped with cooking or laundry facilities.

Since 1980, Vancouver has experienced a steady decline of SRO housing. In 1998 alone, 181 units of SRO housing were eliminated, due in large part to the construction of new condominium developments. In 1998 the Downtown Eastside housed 78.8% of the entire city's SROs.

LOOKOUT EMERGENCY SHELTER

Between 1996 and 1998 the Lookout Emergency Shelter located in the Downtown Eastside provided almost 2,000 men and 700 women with temporary, emergency

shelter. Lookout Emergency Shelter turns away an average of 1,500 men and women each year due to lack of available beds and space.

DAYCARE PROGRAMS AND RATES

In 1998 there were 13 licensed daycare programs in the Downtown Eastside, licensed for a total capacity of 336 children. Government childcare subsidies covered approximately 90% of infant/toddler care, 79% of three- to five-year-old care, and 77% of out-of-school care.

WELFARE

The Downtown Eastside is home to Canada's poorest postal code. A large portion of the population receives social assistance and this neighbourhood has one of the highest rates of unemployment in the country. As of April 1, 2002, welfare rates were reduced for those who have received benefits for a total of 24 months in a 60-month period, and employable singles and employable couples—where both adults are at the limit—are ineligible for benefits. For families with children, rates have been reduced by $100 per month for single parents, $100 per month for two-parent families where one is at the limit, and $200 per month where both parents are at the time limit.

Effective October 2001, the Ministry of Human Resources has provided a monthly nutritional supplement of up to $255 to Disability Benefits recipients who face chronic progressive health deterioration with life-threatening symptoms. To receive these additional benefits a recipient must have a medical condition causing progressive health deterioration, and evidence of specific wasting symptoms including: malnutrition, underweight status, significant weight change, loss of muscle mass, bone density, or moderate to severe immune suppression—conditions that, if left untreated, would put the recipient's life in imminent danger.

LIFE FOR ADDICTED WOMEN

Many women living in the Downtown Eastside have addiction issues and work in the sex trade to support their drug habits. A heroin addict needs to fix every five or six hours just to ward off "dope sickness." Crack addicts feel the symptoms of withdrawal sooner and prefer to smoke this drug on an almost continual basis. Working in the sex trade allows women to make fast money to buy the drugs they crave.

PRICE OF SEX/DRUGS

In Vancouver's sex trade, the Downtown Eastside is "low track." The low track is infamous for attracting the cheapest and the meanest customers in the business. Some men who purchase sexual services on the low track are referred to as "circle jerks" because they drive around the stroll propositioning woman after woman in a search for bargain sex. On "high track," where sex trade workers earn top dollar, the prices are usually "fixed" by the women who work the streets, and sex trade workers who undercut their competition can expect to take some flak from their peers. The women on low track tend to be heavily addicted, and the same price-fixing rules don't apply to their stroll because so many women working the streets are desperate for drugs. When they are dope sick or beginning the involuntary withdrawal process, getting a fix of dope is the only way to make them "better."

The cost of sex on the Downtown Eastside is often proportionate to the cost of getting high. A paper of heroin, enough for a single fix, sells between $10 and $20 a hit. A "rock" of crack cocaine sells for about ten dollars. Many women working the Hastings Strip are "poly-users," drug users who are addicted to more than one substance—often both heroin and cocaine. Illicit drugs on the Downtown Eastside are plentiful and cheap, allowing many residents to develop severe drug habits that need to be continually fed.

MISSING WOMEN

In 1998 the Vancouver police began an investigation into almost forty cases of missing women, many who were known drug-addicted sex trade workers. One woman was found alive and well, two other women were confirmed deceased, and one was labelled as an unidentified overdose victim, leaving approximately thirty-six "missing" women unaccounted for. In the late 1990s there was a sharp increase in the number of women missing from the streets of the Downtown Eastside. Vancouver police responded by assigning a second officer to its missing persons' section. In 1999, the department formed the Missing Women's Review Team amid growing public pressure over the disappearances of so many women; many feared a serial killer was stalking Vancouver's low track prostitutes. The Mayor's office and senior police officers assured the media that they were doing everything possible to solve the cases of the missing women. A $100,000 reward was offered for information and soon afterwards *The Vancouver Sun* published an article suggesting the city's police investigation had been

assigned to inexperienced and overworked officers without the time or resources to do a thorough job.

In 2001 the RCMP and Vancouver police joined forces to replace the city's stymied investigative body. Then, in 2002, the Missing Women's Task Force added more names to the list of missing women from the streets of the Downtown Eastside, bringing the total to fifty. On February 5, 2002, RCMP officers, accompanied by the Missing Women Task Force gained access to a pig farm in Port Coquitlam, British Columbia on a firearms warrant. At the time this piece was written, one of two owners of the pig farm, Robert William Pickton, had been charged with fifteen counts of first-degree murder in relation to the missing women. The Missing Women's file to date has become one of the largest police investigations in Canadian history.

THE VANCOUVER AGREEMENT

Studies into addiction issues facing the Downtown Eastside indicate that the impact of the lack of resources cannot be overstated. In September of 2000, The Vancouver Agreement, representing the three levels of government in Canada, announced a plan to bring treatment services, law enforcement and street improvements together with housing, community and economic development programs. One of its first goals was to end open drug use and drug dealing at the corner of Main and Hastings streets while assisting with the process of getting addicts in touch with health and treatment services. Critics argue that since 2000 the drug trade appears to be less noticeable than before, but it is thriving behind the walls of the hotels lining the Hastings strip.

THE HARM REDUCTION MOVEMENT

A needle exchange program is a service for intravenous drug users that provides them with clean needles, a bleach kit, and education in exchange for used or dirty needles. The goal of a needle exchange is to have injection drug users always using a clean needle, thus reducing the risk of spreading HIV and hepatitis. The recovery of needles is an essential element in these programs to control the unsafe disposal of used needles in streets, playgrounds, etc. All exchange programs provide needles on a one-for-one basis—for every clean needle given, a used needle must be returned. Outside of Vancouver, the only other needle exchange programs in the Lower Mainland are located in New Westminster and Surrey.

The B.C. Ministry of Health allocates $10.5 million in annual funding to a network of community-based HIV/AIDS organizations, including fifteen needle exchanges located across the province. In the space of ten years, the number of needles distributed annually to intravenous drug users had nearly tripled, to almost 3.5 million in the year 2000. While the basic value of needle exchange is widely espoused, critics argue that increasing the amount of money spent on needle exchange programs merely diverts funding from treatment and recovery initiatives.

Needle exchange programs are part of the province's harm reduction approach to decrease the negative consequences of addictive drug use. The controversy with needle exchanges revolves around HIV/AIDS, drug abuse, and crime and safety issues. Safe injection sites are another hot topic in the harm reduction debate. Those in favour of seeing safe injection sites in the Downtown Eastside believe they will promote safe drug use, while critics believe safe injection sites will only serve to promote the use of illicit drugs. Fuelling concerns on both sides is the fact that the Downtown Eastside has been mired in a drug epidemic since the early 1990s. All issues related to addiction and drug use are exacerbated by the supply of cheap, plentiful heroin and cocaine and a shocking lack of accessible treatment programs for addicts.

WHAT IS DETOX?

A detox facility, although not able to provide a cure for drug addiction, can assist a drug addict through the critical phases of drug withdrawal. During the detox phase an addict can experience vomiting, severe body aches and pains, sweating, and in extreme cases, seizures and death. Drug recovery programs are, for the most part, not able to provide detox services—detox facilities are usually separate. Yet, without going through a proper medical detox, addicts are often denied access to long-term recovery programs.

Treatment and recovery resources are very limited on the Downtown Eastside. The number of detox beds available to women in the area fluctuates between five and ten. These resources are available to women from all areas of Vancouver, making it increasingly difficult for women of the Downtown Eastside to get into detox.

ANNUAL NUMBER OF DEATHS FROM ILLICIT DRUG OVERDOSES
IN THE PROVINCE OF BRITISH COLUMBIA

2000: 256	1999: 277	1998: 416	1997: 310	1996: 312
1995: 224	1994: 317			

CAUSES OF MORTALITY

The Vancouver/Richmond Health Board declared in the late 1990s that the Downtown Eastside had an AIDS epidemic. In 2002 the death rate for men due to AIDS is over twice the rate for men elsewhere in the city. Alcohol remains the most lethal health concern for men of the Downtown Eastside as they are, statistically, two and a half times more likely to die of alcohol-related causes than other Vancouver men.

MENTAL HEALTH ISSUES

With only 3% of Vancouver's total population in 1998, the Downtown Eastside claimed to house 18% of the city's population living with mental health issues.

CRIME STATS

In 1992 British Columbia had the highest per capita illicit drug-related costs in all of Canada, and law enforcement costs were in excess of $57 million. In 1997 the estimated costs arising from law enforcement and health care in relation to injection drug use jumped from $57 million in 1992 to $96 million in 1997. Crime against people and property in the Downtown Eastside—homicide, violent crime, auto theft, vandalism and malicious damage—all declined between 1996 and 1998. Studies show that while reduced health costs are impressive, the most positive public return in providing treatment and recovery options to drug addicts is in the reduced costs related to crime.

Contributors

ELAINE ALLAN
Elaine Allan ran a drop-in centre for drug-addicted, sex trade workers on Vancouver's Downtown Eastside for over three years. During this time Ms. Allan witnessed many tragic deaths that occurred due to the city's limited treatment and recovery facilities. As a result, she founded Via Nova Transitional Society, a non-profit, non-denominational organization to provide accessible, 30-day detox services for women. In April 2002, Canadian musicians recorded the CD *A Buried Heart* and dedicated it to Vancouver's fifty missing women, with proceeds from sales going to the Via Nova Transitional Society.

PATRICIA CANNING
Active in the Civil Rights Movement in the late '60s, Ms. Canning's commitment to social justice was partly formed by a Walker Evans photograph she purchased in a Bay Area bookstore for ninety-five cents. The photo was taken for the Fund Security Administration and pictured a line of children holding buckets during the Arkansas flood. Patricia Canning is a collector of 20th century photography and a past-trustee of the Vancouver Art Gallery.

KEN DIETRICH-CAMPBELL
Ken has been active in the Vancouver visual art scene for over ten years. He was the Curator of the Helen Pitt Gallery from 1997-1999 and is currently on the Board of Directors of CARFAC B.C. He holds a M.A. in Psychoanalytic Studies (Brunel University) and a B.A. Double Major (Honours Equivalent) Visual Art Studio, Critical Studies in FPA (Simon Fraser University).

BARBARA HODGSON
Barbara Hodgson is the author of *Opium: A Portrait of the Heavenly Demon* and *In the Arms of Morpheus: The Tragic History of Laudanum, Morphine and Patent Medicines* (Greystone Books).

Lincoln Clarkes was born in Toronto and arrived in Vancouver as a teenager. Originally a painter, Clarkes taught himself photography and went full-time into fashion and portraiture, living and working for a time in London and Paris.

His work has appeared in numerous exhibitions, plus national and international publications. Subjects have included Deborah Harry, Oliver Stone, Helmut Newton and Vivienne Westwood.

In 2001, Peace Arch Entertainment produced the award-winning documentary film *Heroines: A Photographic Obsession*, which opened the Leipzig Documentary Film Festival. Recent work by the photographer includes Burning Man Women (1999), Rodeo Dames LA (2000), Boystown Hustlers (2000), Gutter Punks (2002). Clarkes is represented by the Diane Farris Gallery in Vancouver.

Clarkes resides in Vancouver's Downtown Eastside neighbourhood, a few blocks from where the photographs in this book were taken. He has two grown daughters.